Tamba Pottery

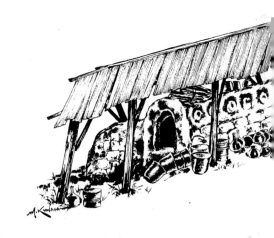

KODANSHA INTERNATIONAL LTD.

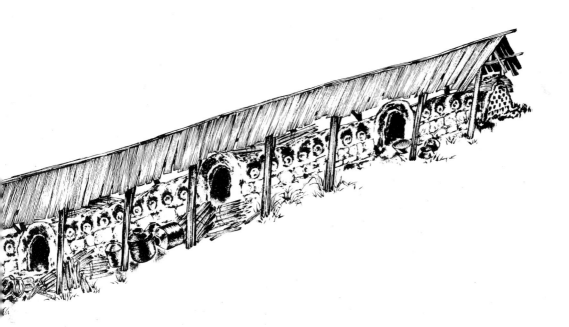

TAMBA POTTERY
THE TIMELESS ART OF
A JAPANESE VILLAGE

BY DANIEL RHODES

DISTRIBUTORS:

British Commonwealth (excluding Canada and the Far East)
WARD LOCK & COMPANY LTD.
London and Sydney

Continental Europe
BOXERBOOKS, INC.
Zurich

The Far East
JAPAN PUBLICATIONS TRADING
COMPANY
C.P.O. Box 722, Tokyo

Published by Kodansha International Ltd., 2–12–21, Otowa, Bunkyo-ku, Tokyo, Japan and Kodansha International/USA, Ltd., 577 College Avenue, Palo Alto, California 94306. Copyright in Japan, 1970, by Kodansha International Ltd. All rights reserved. Printed in Japan.
Library of Congress Catalog Card No. 74–113180
S.B.N. 87011–118–3
J.B.C. No. 1072–781376–2361
First edition, 1970

CONTENTS

PREFACE

AT TAMBA AND the other "Six Ancient Kilns" of Japan, a distinctively Japanese expression in ceramics began to emerge some six hundred years ago. The vigorous, earthy forms made in these old pottery communities are revered as an important part of the nation's heritage, but they are little known in the West. When the great Western collections of Oriental art were formed, the rougher wares of the feudal period were overlooked; today they can be properly seen only in Japan. The purpose of this study is to present in depth the wares of a single area, Tamba, and to trace the history of the kilns at Tachikui, the last pottery village of the Tamba region.

The traditions of Tamba pottery, which reach back to the early Kamakura period, are still very much alive at Tachikui. A study of pottery making at this village furnishes important clues to the understanding of Japanese pottery in general and also reveals much about the nature of pottery as a universal art intimately associated with fundamental human needs. The potters at Tachikui are a link with the past. Such persisting threads of artistic tradition are rare even in Japan and are probably destined to disappear soon. Tachikui is important as the last expression of a long, indigenous development.

Pottery as an art carries a weight of tradition which sometimes stifles growth and creativity. But looking to past traditions for inspiration rather than for models can refresh our vision and put our own problems into perspective. In wares such as

those of Tamba we can find an elusive quality of strength without assertiveness, a calm beauty reflecting a unity of life and art.

The material for this study was mostly gathered during a period of residence in Japan as a Fulbright Research Scholar. As my wife Lillyan and I visited pottery locations, museums and private collections, and felt the special magnetism of Japanese culture and art, our love for Tamba pottery deepened. We found ourselves tracking down pieces wherever we could find them, and my notes eventually grew into the present book.

The Japanese literature on Tamba is not extensive, but the present work owes a great deal to the assistance of Mrs. Robert J. Smith in translating books and articles. Dr. Robert J. Smith of Cornell University read the manuscript and offered many helpful suggestions. I wish to thank also Joyce Benson for help with the manuscript. Countless people in Japan assisted us in our study. The late Dr. Yoshio Saiki of Kyoto made his splendid collection available for study and illustration; Dr. Kiyoshi Horiuchi shared his extensive knowledge and helped with introductions and with interpreting; Mr. Yūzō Kondō, president of the Kyoto Municipal College of Fine Arts made the facilities of the school available to me; Mutsuo Yanagihara gave much practical assistance in work and travel; Teruo Fujieda assisted in interpreting and in collecting study material; Mr. Tōru Nakanishi of Sasayama generously opened up his late father's collection of over fifty years and gave unsparingly of his own time; Mr. Hiroyuki Ichino of Tachikui equally shared his time and his quiet enthusiasm for his art. Gary Snyder, Fred Olson, and Doug Lawrie contributed greatly to our life in Japan and to our understanding of Japanese art. I also wish to express my gratitude to the late Kenkichi Tomimoto for his help and friendship.

Daniel Rhodes

Alfred, New York, 1970

Tamba Pottery

THE TIMELESS ART OF A JAPANESE VILLAGE

The beginning of elegance;

a country rice-planting song.

Matsuo Bashō

INTRODUCTION

JAPANESE POTTERY is so various that it defies generalization as, in fact, do most facets of Japanese history, Japanese art, and Japanese culture. Perhaps this is the reason why those surveys of Japanese ceramics which have been attempted have consisted of little more than a bare outline of certain names, dates, and styles. There is no such thing, actually, as "Japanese pottery," rather, there are numerous wares made at different times and in different places. Few other cultures have produced types of pottery of such widely differing character. When we think of Chinese ceramics, a consistent image comes to mind, which may embrace almost the whole sweep of expression over a period of two thousand years. This is not to deny countless variations and developments, but the inner spirit remains familiar. Greek pottery, although it went through significant historical changes which can aptly be called early, middle, and late, is nevertheless easy to grasp as one rather clearly defined expression of form and of surface decoration. But Japanese pottery has taken so many forms that it is not possible to draw it together into a unified mental image which

can be dealt with as one would deal with, say, Peruvian pottery, or Etruscan pottery. In fact, many Japanese ceramic styles could not contrast more sharply: the delicacy of the Kyushu porcelains is far removed from the rugged rusticity of Iga, for example. Or the subtle decoration of Kutani overglaze designs forms an opposite to the muscular and kinetic quality of Bizen.

The history of Japanese pottery can be followed in terms of progressive changes. The solemn, inward, sacred vessels of the Heian period give way to the more secular and organic designs of early Seto. Later, the influx of Korean potters in southern Japan resulted in new techniques, glazes and sophisticated stoneware and porcelain production. But in addition to these historical developments, there was an intense localism, which has persisted down to the present day. This tendency for local differentiation seems surprising in a small country with a homogeneous population and a single language. But the history of Japan cannot be understood unless the tendency for local autonomy and local cultural differentiation is taken into account. Various communities, even today, have their distinctive kinds of pickles.

After the emergence of the Japanese people as a cultural entity around 600 A.D., it took a whole millennium for the achievement of national unity under one central government. During this long period Japan was divided into many political units, which were often in conflict with one another. Such national identity as existed can be ascribed to a vague loyalty to the emperor, and to hostility towards would-be foreign invaders. Like the mainland of Greece, Japan is geographically divided by relatively impassable highlands, which fence off discrete areas. These areas have developed in relative isolation from the whole. Even today, the traveler on the Tōkaidō, the ancient main highway of Japan and now the route of the

world's fastest railroad, will note the difficult passages from one agricultural plain to another, where the mountains reach the sea and leave no level place for a through road.

Within the cultural and administrative enclaves that made up the totality of Japan, the artist and craftsman worked in relative isolation from his counterparts in the rest of the country. Because of the impracticability of long-distance transportation, local raw materials were relied upon almost exclusively. Local pride and provincial conservatism encouraged a persistence in local ways and styles, and a relative indifference to influences from the outside.

Only in modern times have the Japanese earned their reputation as great imitators. Prior to the opening up of the country to foreign trade in the nineteenth century, Japan had developed a culture which was highly original, and this originality expressed itself in many ways in spite of the overwhelming presence of the older culture of China only a few nautical miles away. Recognition has everywhere been given to the influence of Chinese and Korean ceramics on the Japanese, influences which were inevitable considering the vast head start these countries enjoyed over Japan in the development of techniques. But in fact these influences were rather quickly absorbed. For example, after the wave of Korean influence following the return of Toyotomi Hideyoshi's military assault on Korea, potters had, after about one generation, succeeded in assimilating the new ways of working and in making of them something distinctly Japanese. No one who looks closely could mistake a piece of Karatsu for Korean pottery, nor, for that matter, could Kutani be mistaken for Chinese.

Many Japanese pottery forms seem to have appeared virtually without artistic precedent. No meaningful genealogy can be worked out for Shino wares, or for Oribe and Bizen; these appeared as the productions of local potters in response

to peculiarly Japanese local conditions. Such pottery can hardly be thought of as the result of a ripening of some ancient national tradition. Furthermore, these wares remained the expression of a local style and were not absorbed into other productions or fed into any "mainstream." They were geographically based styles, intimately associated with locale. This point is difficult for us to realize, because in the West we are accustomed to differentiations having more to do either with national peculiarities or with individuation strongly related to innovative persons.

The pottery of Tamba is not a very large part of Japanese ceramics as a whole. In fact, many accounts of Japanese pottery barely mention it. It is not one of the more glamorous kinds of pottery, and few examples of it are to be seen in collections or in museums outside of Japan. Nevertheless, it is one of those expressions in clay which is peculiarly Japanese and one which has had an unusually long history. It was little influenced by and had little influence on other types of pottery. Tamba grew directly out of the social fabric; it was the product of farmers who were close to the basic essentials of existence. It had, therefore, a directness, an honesty, a suitability to purpose and lack of self-consciousness, which have been the mark of the best pottery everywhere.

People sometimes forget that the pottery of the past was made by ordinary men, and that it can best be understood as a part of the fabric of everyday life. True, pottery is in one way a highly abstract form. It refers to nothing outside of itself, except for the bare fact of functional application. Aside from the statement "I am a storage jar," an old Tamba pot must be understood in terms of its inherent and enduring form and surface. But into these are impressed many reflections of a culture.

The cultural factors that were built into old Japanese pottery

have for the most part disappeared. Events of the past century caused drastic changes in Japan and swept away most of those anonymous generating forces which gently brought into being the quiet wares of the tea ceremony, the kitchen, and the barnyard. How can we put ourselves into communication with something so remote, yet something which moves us deeply and directly as we touch the walls of a clay jar? Fortunately Tamba has lived on almost as a fossilized pottery industry to the present day. Cut off from the modern world by geography and economics, it has changed relatively little, and its craftsmen have continued to work much as they did in former times. Through its contemporary state as seen in the pottery village of Tachikui, an insight may be gained into the foundations of one of the central Japanese arts. With Tachikui as a reference, Tamba pottery can be studied not as a group of dead objects in a museum case, but rather as the vital signs of life-force in a community.

Soon Tachikui will change and will come to bear no more relation to its historical past than does present-day Seto or Tajimi. While this inevitable change may bring benefits to its residents and is not necessarily to be deplored, we are approaching the last moment when, through the lives and productions of living potters, the ancient ceramic art of Japan can be felt as a totality.

I first saw Tamba pots at the Japan Folk Art Museum in Tokyo. Although these pots exude an indefinable air of antiquity, they also have a strength and directness rare in any pottery, and a quality of freshness which makes them seem as if they had just emerged from the kiln. The forms of the pots haunted me, perhaps because I knew that neither I, nor any living man for that matter, could fashion such shapes on the potter's wheel. Not because the shapes are especially complex or difficult; the forms are in fact very simple. Rather because

the feeling which had informed the old Tamba potter is a thing forever lost. It occurred to me that perhaps only at the present time could these works be fully read by Westerners, that only now have we grown to a point where bridges exist between Western concepts of art and expression and this pottery of a remote time and place.

This contemporary receptivity to certain old Japanese pots is surely partly the result of the efforts of English and American potters who have discovered through their work a whole set of values dormant in their own traditions. Through a more open-minded and experimental approach to the processes of their craft they have demonstrated the potential of forms, clays, and glazes responding to basic ceramic events not controlled by precise laboratory methods. Suddenly, for them, Japanese pottery became familiar and meaningful.

Later, when I visited the village of Tachikui, I realized that Japanese pottery, at least the kind known as Tamba, cannot be thought of as an art in the usual sense of that word, i.e., symbol-laden objects created by strongly individualistic, master technicians—objects that tend to find a final home in the display cases of the museum. Nor can this pottery be thought of as mere utensils evolved solely to fulfill mundane functions and limited to that status. Rather it is something uncommon to us, something for which we actually have no word. It is a product of the hand which is both functional and spiritual, inextricably bound up with daily life and with aspiration and dream as well.

1. Storage jar. Kamakura period. This ancient pot ▶ seems to breathe. Its ruined lip and kiln scars speak of age, yet it is very much alive in its asymmetry, the mark of the potter's hands. *Height:* 18.1 in.; *Collection:* Tamba Pottery Museum, Sasayama

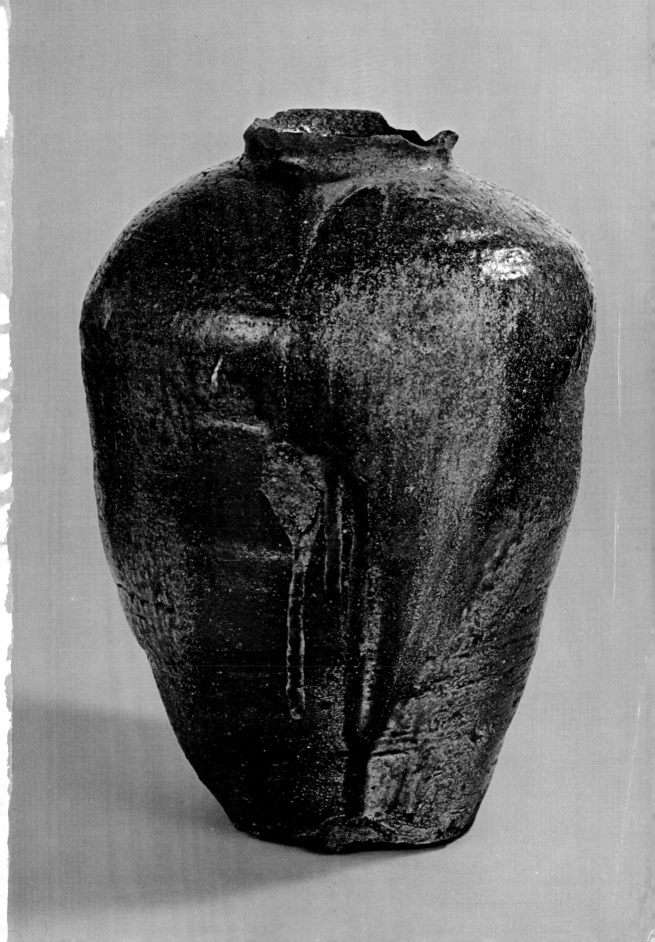

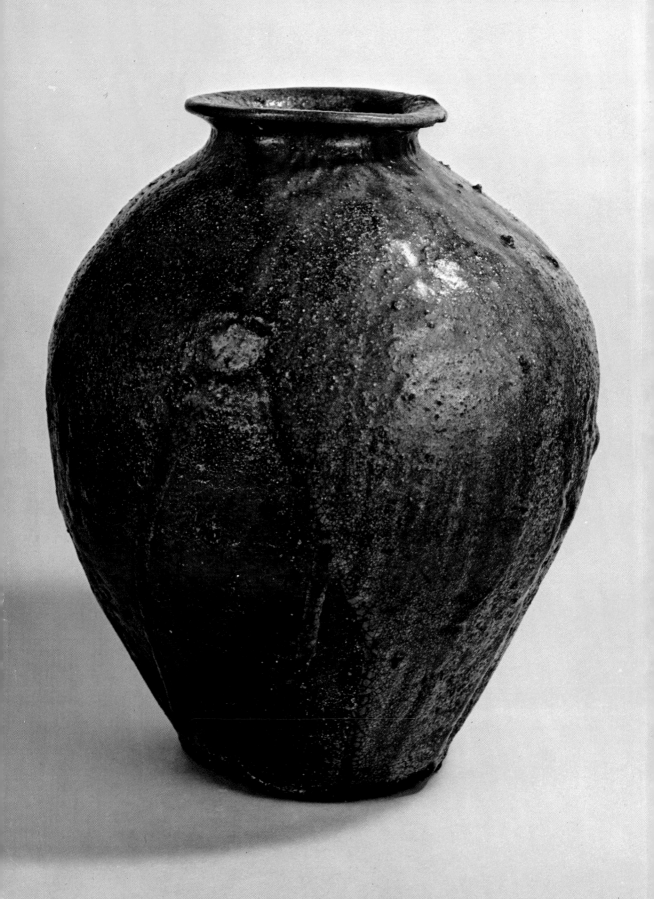

◄2. Storage jar. Kamakura period. This is a classic early Tamba jar with flowing, plastic form and a deep and various natural glaze. *Height:* 15.8 in.; *Collection:* Tamba Pottery Museum, Sasayama

3. Storage jar. Early Edo period. This large piece is glazed with the *akadobe* red glaze, over which has been poured a black glaze, which in this case has broken into colors of blue, cream, and cloudy opalescence. Note the powerful surge of form from foot upward and the climactic bellying of the pot below the collar. *Height:* 24.8 in.; *Collection:* Tamba Pottery Museum, Sasayama

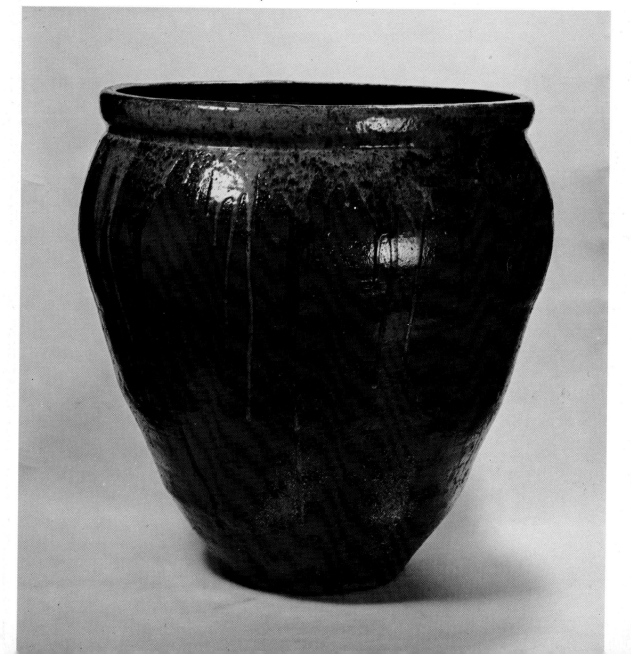

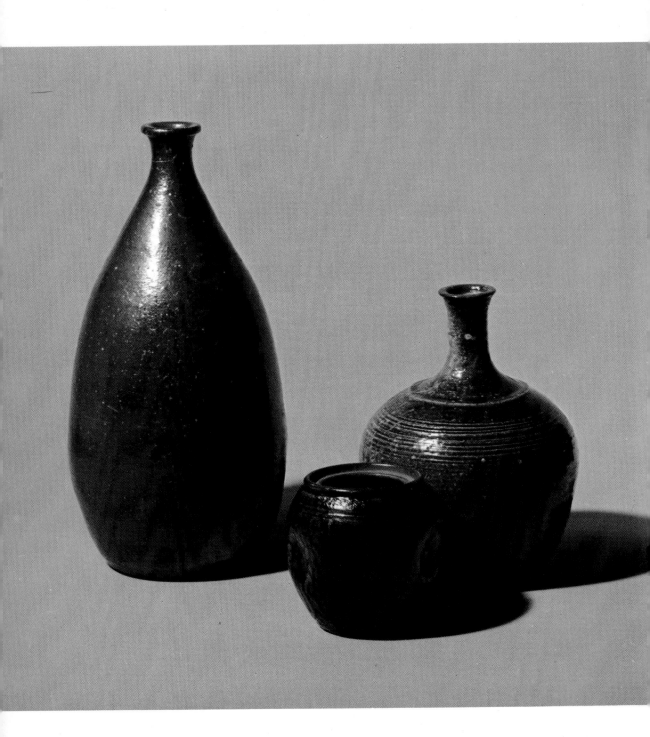

20

◄4. Two saké bottles and small jar. Early Edo period. The large "scallion" saké bottle is glazed with the bright *akadobe* red glaze unique to Tamba. The smaller saké bottle was first glazed with *akadobe* (partially visible on the neck) and then covered with amber ash glaze. The small pot shows the same amber glaze, which has run in rivulets. These glaze colors are typical of early Edo Tamba wares. *Height* (large bottle): 15.0 in.

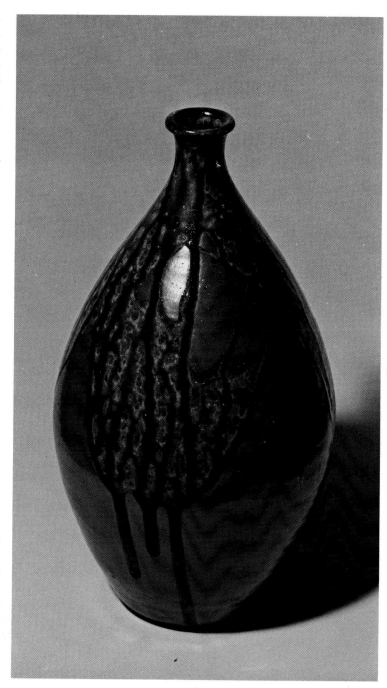

5. Vase by Hiroyuki Ichino. Contemporary. Amber ash glaze which breaks up and runs in rivulets has here been splashed over a brown ash glaze. *Height:* 14.6 in.; *Collection:* Tamba Pottery Museum, Sasayama

7. Echizen storage jar. Muromachi period. This ▶ spectacular jar would seem to have been stacked on its side in the cave kiln to achieve this stormy natural glaze effect. *Height:* 16.9 in.

6. Variety of Tamba shapes. Late Edo to contemporary. Though the pieces shown here could not be called grand or beautiful, they are typical of the production in Tamba from late Edo times to the present day. The speckled vase, the black teapot and the grater dish are modern pieces. *Height* (large jar at right): 17.0 in.

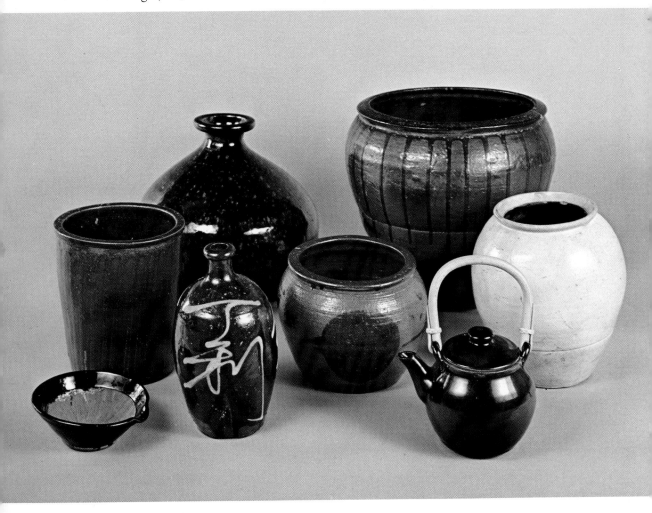

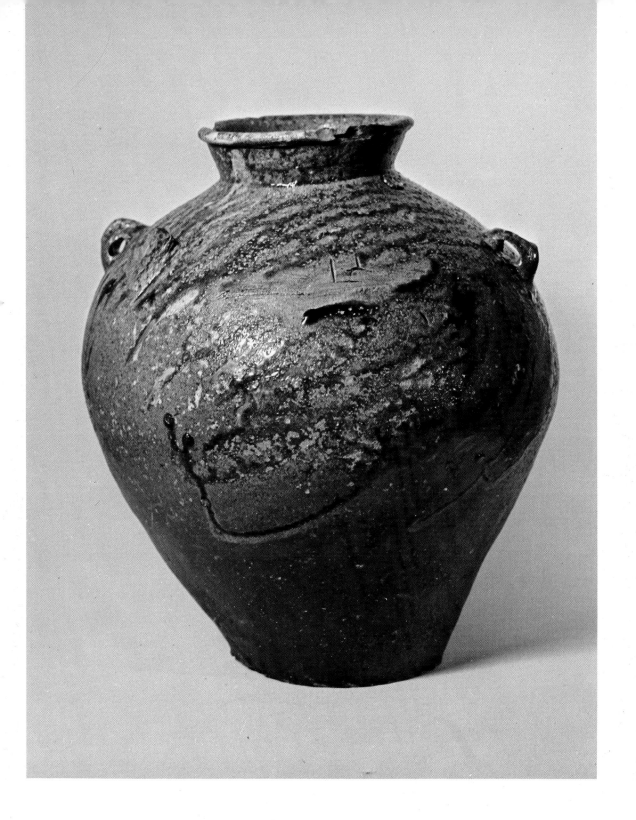

23

8. Tokoname storage jar. Kamakura period. This venerable pot, with its torn lip, irregular natural ash glaze and imbedded kiln debris might be thought of as a prototype for the late Iga wares, in which such kiln events were consciously sought after. *Height:* approx. 17.0 in.

9. Seto jar. Muromachi period. ▶ This black glazed, incised piece, though rarer than the yellow glazed "Old" Seto, shows the work of Seto at its best. *Height:* approx. 16.0 in.

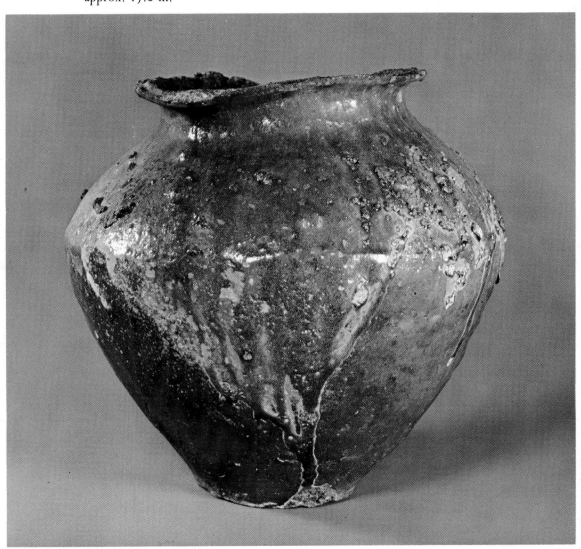

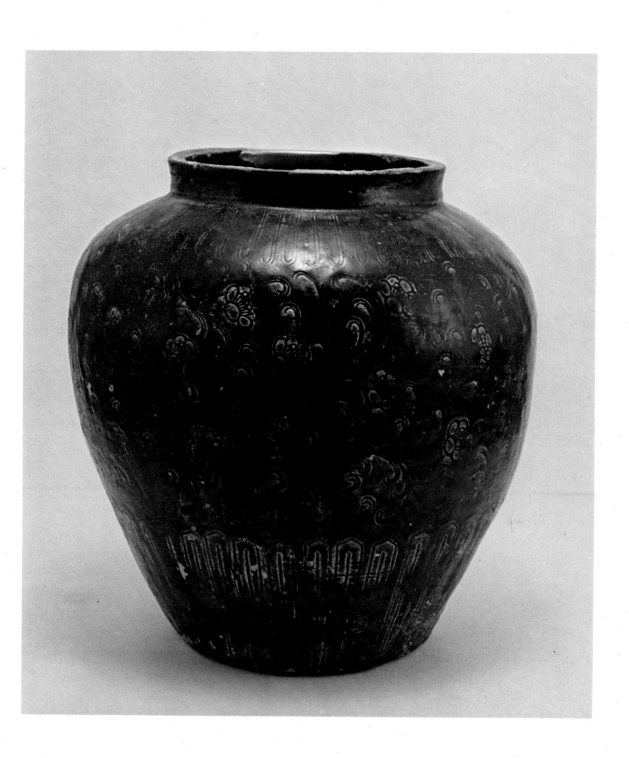

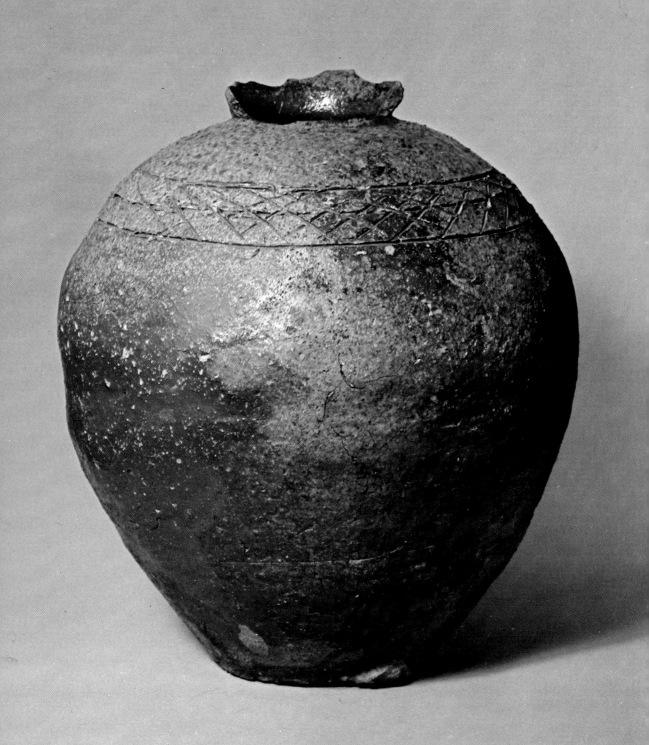

10. Shigaraki storage jar. Late Kamakura period. This globular jar with red scorched clay alternating with areas of thin natural glaze seems to expand limitlessly. *Height:* 17.1 in.

12. Bizen storage jar (*overleaf*). Muromachi period. The variations of firing have given this huge piece a feeling of dark mystery. *Height:* approx. 38.0 in.

11. Iga tea ceremony water jar. Momoyama period. The areas of red scorch lend a forceful contrast to and define the quiet green of the natural glaze. *Height:* approx. 8.0 in.

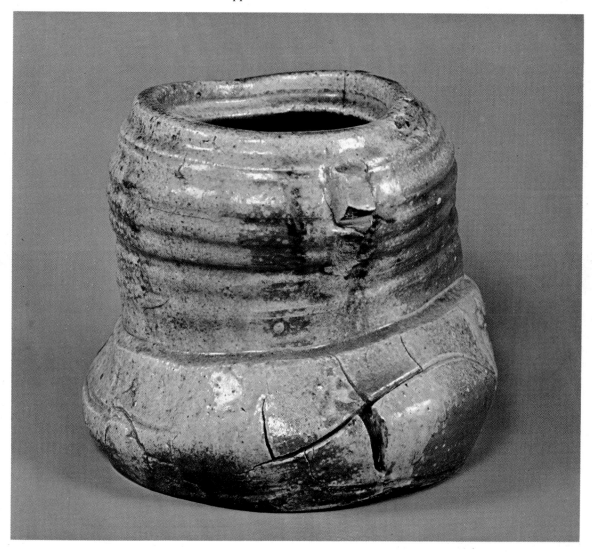

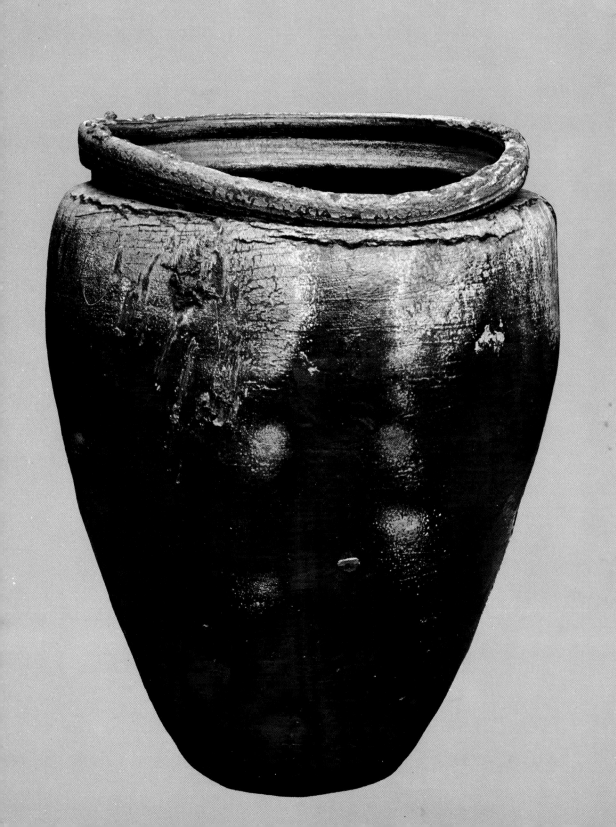

OLD TAMBA

THE HISTORY of pottery at Tamba reaches back into the remote past, and little is known of its beginnings. An obscure and local enterprise, it inspired no written records or commentary, and we must piece together the actual conditions under which artisans in this part of Japan established their workshops and groped towards their own distinctive ways of doing things.

Tamba is the name of an old province in central Japan. Of its seven original fiefs, two are in the modern Hyogo Prefecture, and five are in the present Kyoto Prefecture. Tamba occupied a mountainous region which approached Lake Biwa on the east and the Japan Sea on the north. The ancient highway, San'in-dō, passed through Tamba along a route bordering the Japan Sea. Tamba pottery is a collective name for the pottery made at kilns in the villages of Oji, Inahata, Muramori, Kamaya, Onobara, and Tachikui.

The earliest pottery having a distinct regional character was apparently made in Tamba during the beginning of the Kamakura period, about A.D. 1200, but no actual kiln ruins dating

back to this time have been discovered. At this time the more or less centralized authority of the Heian period (A.D. 794–1185) began to crumble, and the ruling power in Japan passed from the Fujiwara regency, which had exerted its will through the formal structures of the imperial family, to a military government whose capital was in Kamakura. The feudal period began. Through complex arrangements of loyalty and obligations, the local lords, or daimyo, were tied to the military strongmen of Kamakura. The situation in Japan during feudal times was somewhat comparable to that of Europe in the Middle Ages. Local barons, holding their own territory under more or less complete autonomy, nevertheless recognized certain fealties to the military overlord (shogun) and to the emperor, and a system of checks and balances maintained reasonable stability and kept military conflict within certain bounds. During this time, Japan was by no means a unified country. Rather it was a group of small and virtually independent fiefs.

Japan was quite a primitive country during the Kamakura and Muromachi periods. In Tamba there were no cities, and few settlements that could even be called towns. The economy was almost exclusively agrarian, and the production of goods was entirely decentralized and on a small scale. Transportation hardly existed, and traffic between the various provinces was minimal and uncertain. In fact, war served as the principal means of communication between the various regions. The more remote provinces, of which Tamba was one, were sparsely populated, and the extensive irrigation systems that later were to expand the extent of usable agricultural land had not yet been built. The occasional fortresses, with their surrounding compounds which sheltered activities supporting the seat of power, served as the nerve centers of the society. The vast majority of the people were illiterate serfs who worked the land generation after generation, scarcely conscious of,

and certainly not knowledgeable about, anything outside their own immediate areas, much less the outside world. The pace of change was so slow as to be almost imperceptible to any particular generation. Contacts with China and Korea were so fitful and uncertain that only a minimal cultural exchange occurred for centuries. The Chinese knew of the Japanese islands largely through the much feared activities of pirates, and the Japanese were conscious of Chinese culture mostly from the surviving influences of the earlier Nara and Heian periods, when international traffic had been more active.

In some ways this period was one of cultural decline. The elegant and largely imported ways of the court had less influence than formerly, and things Chinese were less revered. Each province was more isolated and thrown upon its own resources. But during the Kamakura period a gradual crystallization of Japanese culture occurred, and purely Japanese forms of art, thought and religion emerged. During this period Zen Buddhism became established. Although it was a sect originating in China and based on a fusion of Taoist and Buddhist elements, it soon took on a Japanese character and became a pervasive cultural force. A wonderfully distinctive style of sculpture, very un-Chinese, was formed. Most important for the present study, Japanese ceramics emerged with an original and purely Japanese character.

The peasant potters working in Tamba during the Kamakura and Muromachi periods would have been very surprised to learn that their work had any lasting significance, which would be worthy of mention hundreds of years later. And, in fact, what they were doing was primarily just a part of the daily work, of the struggle for survival. The first potters to set up shop in Tamba may have come from other provinces. There is a story that one Furoyabu Sōtarō came to Tamba during the Heian period from Yamaguchi and set up a kiln at Onobara. This

man is thought of as the "ancestor potter" of the region. He is possibly a legendary figure, since at the time indicated there were no such names as his in use in Japan. But when Tachikui village was founded in 1184, Furoyabu Sōtatō was enshrined as the titular diety of the *Tōki-jinja* ("Ceramic Shrine").

In fact, some pottery had been made in the Tamba province from as early as the ninth century. This was the Sue pottery: a gray, hard-fired burial ware, very similar to the wares of the Silla dynasty (57 B.C.–A.D. 935) in Korea. It is possible that potters who were skilled at making Sue pottery stayed in the province during the upheavals of the Kamakura period, and that subtle changes over the years brought forth the typical Tamba ware. More likely, the shops which had made Sue wares, (shops which must have been quite well organized and which certainly had a high degree of craftmanship, probably sustained by some sort of apprentice training) simply went out of business or gradually ceased production as changing burial customs, diminishing patronage from the nobility and the introduction of lacquer wares for ceremonial use decreased demand. In any case, Sue production at Tamba must have been quite small, at least compared to that of Seto and other pottery producing areas, and it had no local character, being part of a widespread and rather uniform style of pottery making which was perhaps controlled by the Shinto priesthood. Sue pottery produced at Tamba was not made for daily use or for the peasantry; it was used as funerary ware and buried with the dead.

Although the style of Tamba pottery owes little to Sue prototypes, the question remains as to whether the techniques of throwing and firing were directly passed on from shops making Sue to the local potters. There is no way of settling this point. But since there is a rather drastic difference between Sue pottery and the first distinctive Tamba pots, it can be assumed that there was a considerable gap between them, and

that no smooth transition occurred from one style to the other. Tamba pottery not only looks different, it functioned in the society in an entirely different way than the Sue ware.

The need for pottery in an agricultural society such as that of Tamba was urgent. Containers were needed for storing the rice seeds from one season to the next, and the seed had to be protected from dampness and from rodents. Wooden containers admit moisture and are difficult to make. Metal was out of the question because of its scarcity, and in any case all metal was reserved for use in weapons and for tools. Waterproof containers were needed for storing water, and for the collection of offal for use as fertilizer. And primitive as kitchen techniques undoubtedly were at that time, pottery vessels, which could be used for heating food and for storage, and which were durable and cleanable, were then, as now, important to daily life.

Given this need, it is rather strange that pottery production in Japan actually declined during the Kamakura period, and that only a few localities were actively producing wares for daily use. Since the materials were widely available and the skills of the Sue production must have survived to some extent, it is hard to account for this decline of pottery making. There seems to be no explanation as to why Tamba should have been one of the few places where pottery production flourished. The available clay is neither plentiful nor of high quality. Some chance happening, such as the arrival in the district of some family or group who knew how to make pottery, or the interest and encouragement of some daimyo, may have been more of a factor than any matter of economics. The early kilns were apparently located near the village of Onohara. A little later, production was begun at Tachikui, and these two localities remained the main pottery places down to modern times, though today only the latter has maintained the industry.

Production was no doubt small at first, perhaps sufficient only for the needs of the local population. But there was a gradual increase, and by the beginning of the Momoyama period, *ca.* 1573, as many as one hundred thousand pieces a year were being made. The bulk of this production was used within the province, but some pieces found their way to other parts of Japan. Old Tamba pots have turned up in many places in Japan, but the trade and transport systems which brought them there are not well understood. Even today, Tamba potters have trouble reaching a wide market for their pots, and this must have been a problem from the first.

The most common form of old Tamba ware is the storage jar. These multipurpose pieces were used for grain, seed or water storage, and for pickling. They are usually less than twenty-four inches in height. The base is flat, fairly small in diameter, and is not trimmed into a foot ring. The mouth of the jar, usually about six or seven inches wide, gives a sense of constriction at the top (Pls. 1, 2) but is amply wide to admit the hand. In many of the earliest examples, the lip turns outward somewhat; the later jars tend to have a more vertical neck and a thicker lip with less flare. The belly of the typical jar swells out voluminously, and always there is a feeling of strong, virile, elemental form. The jars are usually quite asymmetrical, the larger specimens, especially, tending to be lopsided (Pl. 13).

Old Tamba pottery production seems to have been limited to a very few shapes. Toilet jars were made, which were considerably larger than the storage jars and which had a wide mouth, but surviving examples of these are quite rare. More common are the grater dishes. These are rather flat bowls which have a rough interior made by scoring the surface of the soft clay with a toothed tool like a comb. These grater dishes were used to grate radishes, horseradish, and ginger; similar dishes are still made by many potteries and are used in every Japanese

kitchen. Bottles for saké were also made. These are narrow-necked vessels about six or seven inches high with a rounded belly. None of these early Tamba forms was glazed before firing, and whatever glaze occurs was the result of accidental glazing in the fire. The clay is rather coarse and is fired to a dark red-brown or gray-brown color.

The first kilns at Tamba were small compared to the modern ones, and it seems probable that the pottery shops were small and were run as family units involving no more than a few workers. Invariably, the ruins of the old kilns have been found in the higher slopes of the hills. The dwellings, then as now, were located below in the flat valley bottoms. It is not known whether the potters camped in the hills part of the time while pottery making was going on or traveled each day up the steep slopes to the kilns. A likely possibility is that the shops were located below on the plain, and that the pots were carried up the hill for firing. Two factors probably influenced the choice of the hill locations for the kilns: the ready availability there of wood for firing, and the right soil conditions and land contour for the construction of the cavelike kilns.

Examination of old Tamba jars leaves little question as to the processes by which they were made. The clay was dug out of the ground and used with little or no processing. Granules and mineral fragments are common in the clay and indicate that no refining process such as floatation and settling was employed. The clay was simply wet down with water and was probably stored in large lumps or piles, then further tempered with water and kneaded for use on the wheel. The wheels were slow turning and had little momentum. They were operated by foot. The bottom of the jar was formed by beating out a slab or disc of clay on the wooden wheel head, which had been first dusted with a bit of fire ash to keep the clay from sticking. The body of the jar was usually made in three stages. A fat coil

of clay was added to the base, then squeezed or thrown on the slowly revolving wheel to form the bottom third of the piece. Two more coils were added, each thrown and shaped in turn. The joinings of these coils are clearly evident on many Tamba pieces, and the addition of the second coil, especially, frequently resulted in irregularity of shape. Although the widest part of the jar is usually quite off-center, the lip is more apt to be well thrown, circular and refined in form. The wheel was rotated counterclockwise. Judging somewhat by the pace of present-day Japanese potters using similar methods of forming, it probably took from fifteen minutes to one-half hour to make a storage jar eighteen inches tall. This is not especially rapid production, and the old Tamba pieces have the look of having been made rather slowly and deliberately. One never sees an old Tamba pot which was insensitively or perfunctorily made. All surviving examples seem to have a sensitive form and subtle undulations very expressive both of the interior volume and of the tender touch of the potter. While to some the asymmetrical shape of the pots may suggest a lack of craftmanship or lack of attention to detail, this is not really the case. The jars are well made on their own terms. They are sturdy, uniform in wall thickness and they invariably have a fresh, plastic, claylike quality. The freshly thrown jars were not cut from the wheel with thread or string, but were either pried off the wheel head with a flat tool, or were allowed to dry on a wooden bat which had been attached to the wheel during throwing, and then removed when the piece was finished. There is seldom any evidence of deformation of the piece from being handled while wet and soft.

No two Tamba pieces are ever exactly alike, and it is unusual to find two that come even close to being identical in size, shape and color. The products of the various kilns and shops were dispersed and separated so long ago that it is not

possible to compare two jars made at the same kiln at one particular time. But if such a comparison could be made, perhaps a degree of similarity would be observed.

The dry pots were moved directly into the kiln without glaze or decoration. The primitive kilns of early Tamba were no doubt the same type as those used in Korea during the Silla period and those used in Japan for the production of the Sue ware. Although the kilns were rudimentary by modern standards, their operation enabled sufficiently high temperatures to produce hard, vitreous pottery.

This type of kiln, called *anagama* (literally, "hole kiln"), was constructed by digging a cave or tunnel into the brow of a hill. The kiln had to be located where the soil conditions and the land contour were favorable. Necessary was a sandy soil containing a percentage of clay and little or no rock. The presence of limestone or shale would preclude the construction of a successful kiln of this sort because fragments of such rock would upset the stability of the walls of the kiln during firing. The ground had to be sufficiently compacted to permit the digging of the tunnel without shoring up inside. The entrance to the tunnel was made just big enough to permit a man to crawl in, about two feet wide and two and one-half feet high. A few kilns that specialized in making larger shapes, such as the toilet jars, must have had bigger entrances. Past the entrance hole, the kiln was widened out to form a firing chamber about nine feet long, five feet wide, and three and one-half feet high. The chamber sloped upward at an angle of about twenty-five degrees. Rising from the upper end of the firing chamber was the flue, about a foot and one-half in diameter. The length of the flue was determined by the contour of the slope, but in any case was no more than six to ten feet in length; there was no chimney (Fig. 1, p. 47).

This cave structure, although it was achieved by burrowing

into the ground rather than by the construction of a free-standing form, had all the essential elements of any pottery kiln. There was a fire mouth where the fuel could be burned and the heat introduced. Next it had a chamber in which the ware to be fired could be placed and in which the heat could be trapped and accumulated. Finally, it had a flue or exit through which the spent gases could be exhausted. Since the whole structure sloped upward, the gases moved through it by convection, furnishing sufficient draft to pull in the air necessary for the rapid combustion of wood.

While the construction of such a kiln involved no great feat of engineering, it must have been a problem to complete the structure without cave-ins. Before firing, the walls of the cave must have been soft and crumbly, and working inside must have involved some danger. But when the kiln was fired, the intense heat sintered the walls of the cave, hardening the surface into a tough, self-supporting structure. Once fired a few times, the interior crust of the kiln became sufficiently hard as to almost preclude collapse, and the more the kiln was fired, the more permanent and solid it became. The fact that some of these old cave kilns have survived as ruins down to the present time attests to their durability (Pl. 77).

To set the kiln, the potters crawled through the fire mouth into the kiln, and the pots were passed from one person to another to the inside. The pots were placed directly on the floor of the kiln, and a wedge-shaped pad of clay was placed under each pot to make it stand level on the sloping surface. The remains of these clay pads, frequently found among the shards in the neighborhood of old kiln sites, give an accurate index of the slope of the kiln. Pots were set one on the other in tiers and layers to the height of the kiln. Work on the inside of the kiln must have been lighted by torch or lamp. The back part of the kiln was, of course, stacked first.

While the exact firing cycle used in the old kilns cannot be known, it was, then as now, a matter of burning fuel in the fire mouth, slowly at first and with increasing intensity until the desired temperature was reached. The firings were extended, no doubt lasting for several days. Cypress and pine wood, formerly abundant in Tamba, was used for fuel. A maximum of about 1200°C. was the usual top temperature. The advance of heat was gauged entirely by eye, and actually, since no spy hole looked into the interior of the kiln, the temperature must have been judged by the observed heat in the fire mouth. Under these conditions, considerable variation must have occurred between the different firings. Judging by the color of the fired pieces, the kiln atmosphere was neutral: neither heavily reducing nor oxidizing.

Old Tamba pots have a singularly rich surface color and texture as a result of the firing process to which they were subjected. These surface features resulted entirely from firing rather than from design. The passage of flame through the open setting of the kiln gave an irregular fire color, flashing some pieces more than others and imparting a variety of fired color to the clay.

A notable feature of old Tamba pieces is the coating of glaze which commonly covers the shoulders of the pots, and which frequently runs down toward the base in streaks or rivulets. This natural glaze coating is called *bidoro* by the Japanese. It was caused by a deposit of ash from the fire, which settled on the upper surfaces of the pieces and fused into a glass. This natural ash glazing is a prominent feature of much old Japanese pottery. Far from being a superficial form of decoration, it was rather an inevitable result of the way the pottery was placed in the kiln and fired.

When wood is completely burned, the residue of ash is composed of the inorganic elements that have been stored up in

the plant through the action of the roots in the soil. Each plant selects from the soil in which it grows a characteristic balance of the various elements, such as silica, alumina, potassium and sodium. Such inorganic substances make up a very small percentage of wood, usually less than two percent by weight. The rest of the wood is made up of hydrocarbons, which are volatalized as gas during combustion. At temperatures above about 1150° C., wood ash is fusible and will melt to a glass, especially if it can combine with additional alumina and silica. The ashes of coniferous trees such as pine, cedar, cypress and the like are especially fusible. The ashes of the hardwoods and of grasses, straw, corn husks, and bamboo are somewhat less fusible. When a pottery kiln is fired to high temperatures with wood, considerable quantities of fuel are consumed, and a large amount of ash is formed. The draft, sweeping up through the firing chamber, carries with it a certain amount of ash in the form of fine dust. This ash settles on the ware, especially on the upper rims and shoulders of the pieces, where the more or less horizontal surface tends to hold it. When the temperature in the kiln approaches 1200°C., the ash begins to fuse on the pottery, combining with some of the silica and alumina at the surface of the clay. After a more or less viscous coating of molten glass has been formed on parts of the pottery, still more ash is caught in it, like dust catching on a sticky surface coated with honey or molasses. Continued firing and the buildup of a thicker deposit causes the molten glass to flow down the vertical walls of the pots in runs or drips. The position, the extent and flow of the ash glaze depends on the placement of the pot in the kiln, the duration of fire, and the temperature achieved.

The extensive and often thick coatings of such ash glazes on old Tamba pots indicate a long firing cycle, for only an extended period of firing would have generated such quantities of ash. In an efficient and well-insulated pottery kiln, using wood for

fuel, high temperatures can be reached in a relatively short firing time, and only minor ash glazing will be observed on the ware. In the old Tamba cave kilns, it is probable that a long fire was necessary because of the dampness of the earth in which the chamber was dug. Many hours, or days, of firing must have been required before the moisture was driven from the walls of the chamber. Until the kiln was dry, no great buildup of heat could occur. During this extended early phase of firing, quantities of ash would pass through the ring chamber. Considering the labor required to cut and split wood, even assuming that the wood was plentiful and nearby, it is unlikely that the potters would have extended the firing time just to favor accidental glazing. It is possible that improperly dried wood, or wood that was not split into sufficiently small pieces may also have lengthened the firing. But for whatever cause, it is certain from the evidence of the pots themselves that the firing time in the old kilns was very much more extended than is common today. The firings probably lasted for five days or even longer.

The color and texture of the natural ash glazes on old Tamba pottery are extremely various and interesting. Where the ash glaze is thin the surface effect may be somewhat similar to salt glazing. The thinly glazed clay appears tan, gray or reddish brown. Where the glaze has built up in a thick coating, it is usually cool in tone and tends to be green, gray or even bluish with considerable streaking and mingling of color. The contrast between the warm color of the thinly glazed areas and the cool, glassy, thickly coated areas is striking.

The atmosphere of the kiln appears to have been largely neutral, although there is considerable variation, and some pieces show more reduction effects than others. The thicker parts of the ash glaze are frequently cool in tone, sometimes close to a celadon (Pl. 2). Since the pots were fired in the open without saggers, and were subject to flashing and the direct

effect of flame, a great deal of variation is often seen on one piece. But the predominant tonality is warm gray, reddish brown or tan where the clay body is bare or thinly covered, and cool gray to green where the glaze is thicker.

Besides the natural ash glaze, certain other surface features resulted from the firing process. Very commonly, the upper surfaces of the pots are marked by fired granules adhering to the glaze (Pl. 23). There are crumbs from the ceiling of the kiln that became dislodged during firing and dropped down on the pots. Each heating loosened a certain amount of material from the sintered earth surface of the kiln, and when such fragments fell on the tacky glaze they stuck. Large hunks as big as walnuts are not uncommon. Besides the material which dropped from the kiln ceiling, the manner of setting the pieces in the kiln also gave certain irregularities to the surface and form. Where the pieces touched as they were stacked one on top of the other a scar often occurred as the result of the breaking apart of two pieces stuck together during firing (Pl. 28.). Pieces which were wedged into one another frequently show a deformation of form, dents, bulges, or warps, which occurred as the clay softened in the fire and gave way to pressures from the pieces above them (Pl. 18). All of these events of making and firing combined to produce pots which are infinitely various. The pots relate to each other more like a collection of pebbles on the beach than like peas in a pod.

The old Tamba pots are relics of a simple, unsophisticated, peasant industry. The methods employed were direct, un-complicated and conceived in terms of the available local materials. Without exception, the forms were practical answers to everyday needs. The potters were men whose lives were concerned with immediate and basic problems. They practiced their trade with skill, but they were certainly not knowledgeable about the world at large or able to relate their

own work to the pottery of other places and cultures. Yet these old pots have a sureness of form, a perfect suitability to function and a variety and mystery of surface which place them unquestionably among the great expressions of the potter's art. But the Tamba potters were certainly not artists in the sense which we use the term today. They worked at their craft as a daily necessity, probably unaware of any such concept as "art." Their achievements were collective rather than individual. Their expression was deep, quiet, almost instinctual, embodying feelings of a whole society rather than that of particular persons.

From our point of view, looking as we can over the whole sweep of Japanese history, the old Tamba wares might be considered as a development of the earlier Sue wares, to which they are related in technique, if not in form. But it is very doubtful if the potters themselves were aware of any such connection. If a Tamba potter of the fourteenth century saw a Sue pot, he would probably have regarded it as the work of some remote past, and in fact, at the time of the Kamakura period, Sue production had been in decline for over two hundred years, and even the function of the earlier ware was by that time probably forgotten. In this sense Tamba pottery was more or less cut off by the passage of time from any tradition that was different from itself, and the potters could not have regarded themselves as having been the instruments of a development which had brought about changes or consolidated an earlier art. The pottery is rather the outcome of a stable, localized tradition, which was almost entirely lacking in the dynamics of social or stylistic change.

If old Tamba pottery was virtually independent of any conscious continuation of earlier Japanese traditions, it was even farther removed from foreign influence. Of course, it is possible that the potters at Tamba may have seen some Chinese

pottery, which was certainly known and admired by many in the cities, and it is even more likely that they may have seen glazed pieces from Seto made in the Chinese style. But no trace of Chinese influence is evident in the early Tamba pots. Since applied glazes were unknown at Tamba in the early period, it would have been impossible for the potters there to produce anything remotely Chinese in character, even if they had desired to do so. Likewise, Korean influence was nonexistent. The beautiful celadons of the Koryo dynasty (A.D. 935–1392) had no echo in Japanese country wares.

Tamba was mountainous, difficult of access, thinly populated, and had little regular interchange with neighboring regions. To the natural obstacles of geography were added the hazards of banditry and of armed hostilities between warring factions. Each province relied largely on its own resources. There was probably little or no exchange of information and persons between the potteries at Tamba and those at Echizen, but there may have been some awareness of those wares which found their way in quantity to Kyoto. Bizen, Shigaraki, and Tokoname were surely little known. We might picture the isolation of the feudal Japanese communities as being similar to the situation of the Appalachian hill dwellers during the nineteenth century. They were Americans and they spoke English, but they did not rely significantly on regular communications with the world outside their own mountain fastness. It is probable that the parallel developments in the ceramics produced at Bizen and Shigaraki resulted from similar circumstances, rather than from the influence of one community on another.

Tamba pottery grew out of the profound conservatism, traditionalism and localism of the early Japanese community. Change occurred slowly. By about the year 1300, the storage jar form—its general shape, style of potting and "feel"—was

set. From that time until about 1550 the jars were produced without radical change in form or surface, a period of over 250 years. Change was so slow as to be almost imperceptible to any one generation, and at any given point of time the potters must have felt that their works, their craft and their lives were almost as fixed and as immutable as the hills. They could imagine no future for their children which was much different from their own fate. They surely did not see their pots as part of a developing, emerging activity, and they had little concept of progress. Nor could they have seen their pots as the culmination of some long development—they were unaware of any such development. In such a stable and unchanging environment, even the desire for change or progress must have been almost nonexistent.

During this span of time, ten generations of potters were born, worked, and died.

A surprising number of old Tamba jars have survived to the present in spite of the fact that they were in daily use and were not buried, stored, or preserved as objects of special value. Most of the pottery of the ancients of various cultures has been preserved only because it was buried with the dead. This is true of nearly all old Korean pottery, and much of the surviving pottery of China made prior to the Sung dynasty was preserved in graves. The Japanese have a veneration for old things, and tend to keep favorite household articles for generation after generation. The old Tamba pots survived on the farms for hundreds of years, and one can be sure that they were not kept on the shelf or regarded as precious works of art. They were used. A deep respect for craft and perhaps also a love of form and texture for their own sake prevented the careless handling or indifference which would have quickly destroyed all the earlier pieces. The pieces were certainly not preserved because they had any monetary value, because until very recently

Tamba wares were not collected or much valued by connoisseurs. In Kyushu I have seen Onda and Koishibara pots perhaps one hundred years old still in use on the farms. They are casually used in the barnyard, kept on the ground, and given everyday treatment, but still they are rarely broken. Tea stores and cloth dyeing establishments in Japan frequently use pottery jars which are very old, and in some Kyoto shops one can see rows of tea jars on the shelves which are at least three hundred years old. Also significant is the fact that the Japanese kept pottery jars for generations even though they may have had obvious flaws of manufacture such as warped form, bits of clay from the kiln stuck in the glaze, or a broken rim.

Our vocabulary is almost inadequate to describe certain old Tamba pots. One who is not tuned to the subtle values of pottery as an art form might at first be inclined to dismiss them as being rather stolid and uninteresting forms, lacking in color and certainly without decorative interest. The pots undoubtedly are completely removed from anything reflecting individual expressiveness, cleverness, colorfulness or originality. Yet after considering their history, the functional reasons for the forms and all the known details of the manufacture and usage of these old pots, some quality, hard to define, transcends all the data. Some ineffable spirit attaches to them. That overworked Japanese word *shibui* might properly be used here—quiet, unassuming, astringent, low-keyed, understated, inward— these are some of the words with which one gropes for the untranslatable meaning.

The old Tamba jar rises from a sturdy base that is flat, forthright and rooted. The form swells out, but under a constraint which seems to inhibit any sudden turn or eccentricity of form. The shoulder is broad, sure, firm and generous, ''like the shoulders of a Jizō,'' as the potters at Tachikui say. (Stone images of Jizō, the protector of children, are ubiquitous

in Japan.) The shape turns inward, never too sharply, toward the collar and lip. The events of the fire have usually blessed this part of the vessel, and the heightened color and texture about the top draw our attention to the opening, just large enough for the hand, and giving a glimpse of the dim interior. The lip of the jar is always strongly shaped with a well-marked roll of clay at the edge, or fingering marks building up to the edge. But these marks of the wheel are never dominant, nor do they seem to be displayed for their own sake—they are just there as a natural mark of process, neither erased by trimming and scraping nor flaunted as a mark of skill or as evidence of ''design.''

''Design'' is a word which can hardly be applied to an old Tamba pot. The jar ''happens.'' It seems to have formed itself. And surely the potter must have felt that way about it. He must have turned out his quota of jars each day with little thought of the individuality of each piece. Through his workmanship, the clay, the water, the rhythm of the wheel, and the fire came together. The feeling and creative urge which prompted the shaping of these pots operated at the deeper levels of group consciousness. Although shaped by individuals, the pots express a whole culture, an attitude, a way of living and working. These things were certainly expressed in other ways as well—in dress, in architecture, in the pattern given to the fields by the plow and the rice plantings.

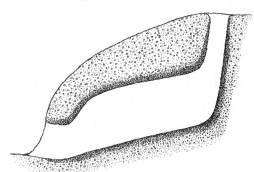

Fig. 1. *Anagama* or cave kiln.

13. Storage jar. Kamakura period. The deformation of this piece makes it seem like a pot just taken from the wheel. The base has sagged so much that the piece cannot stand upright. *Height:* 22.9 in.; *Collection:* Tamba Pottery Museum, Sasayama

14. Storage jar (*facing page*). Late Kamakura or early Muromachi period. This piece has an unusually complete glaze with runs which reach from the lip to the base. The color ranges from gray green to deep brown. *Height:* 17.5 in.; *Collection:* Dr. Roger Gerry ▶

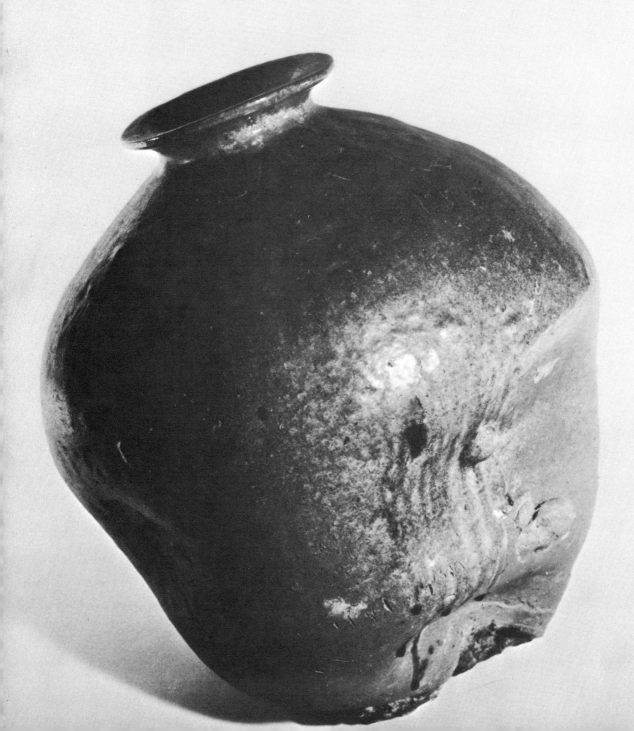

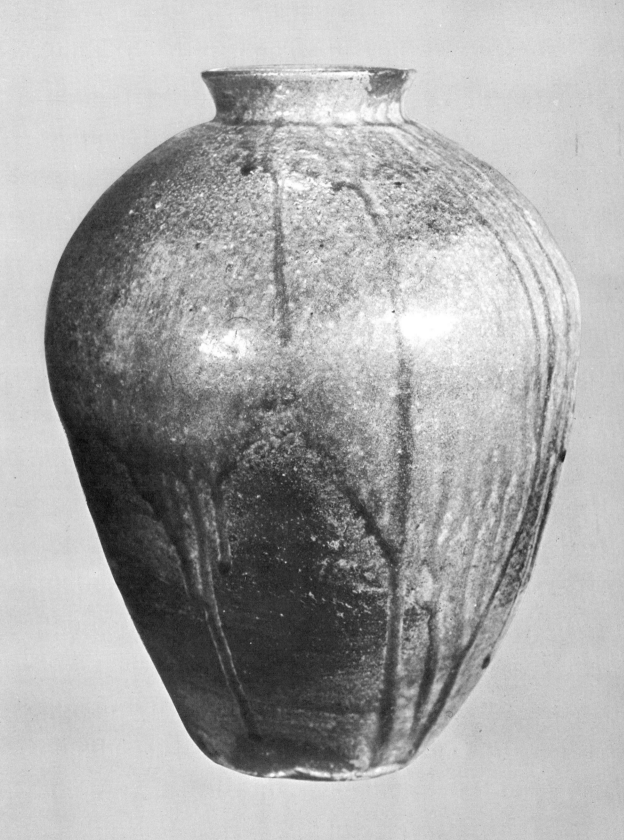

15. Storage jar. Muromachi period. Although the
natural ash glaze on this piece is relatively thin, it
creates a spectacular interplay of warm and cool
colors. The flow of the glaze down the wall of the pot
suggests a stream of water over sand. *Height*: 16.5 in.
Collection: Earl Morse

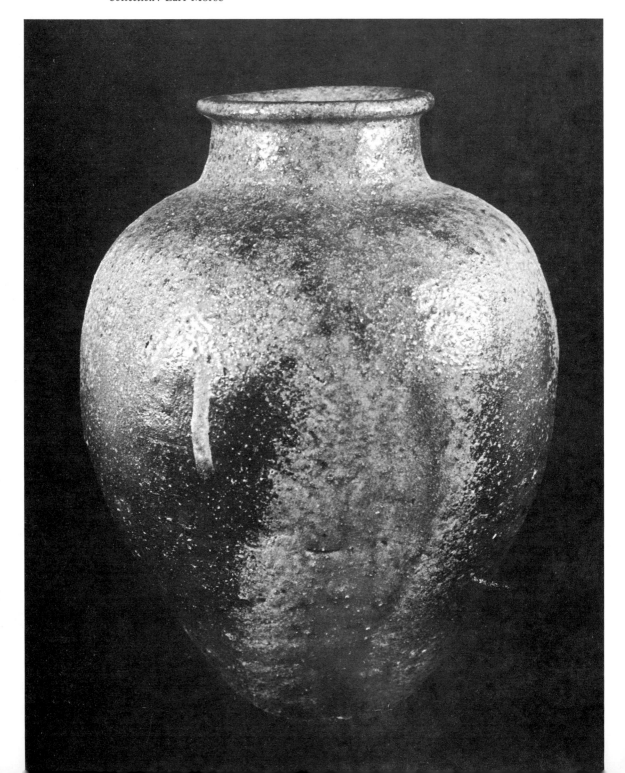

16. Storage jar. Muromachi period. The inscription on the shoulder of this jar gives the date of Kōei 3, (1344). The closely controlled form and the sharply defined neck and lip give this piece a closer relationship to Sue wares than the later Tamba pieces. *Height:* 20.2 in.

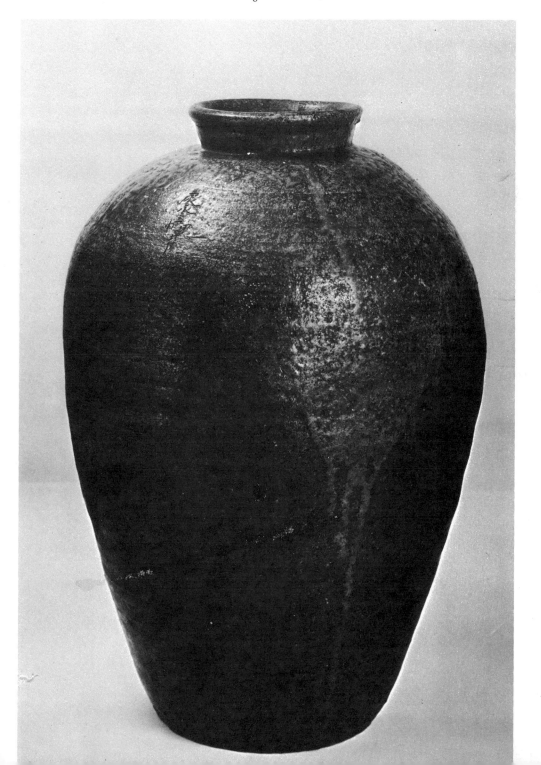

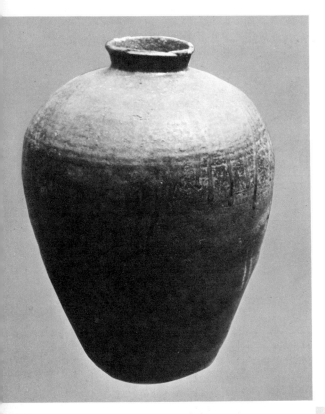

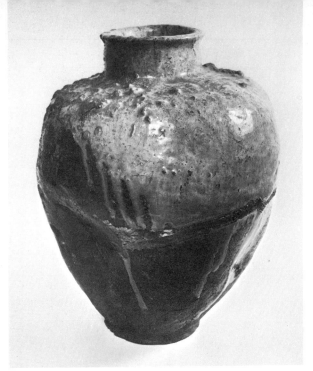

18. Storage jar. Muromachi period. The hunched shoulder of this magnificent piece gives it a strong, aggressive character. The flaws only add to the vivid quality of the piece, also enhanced by the heavy cream-colored natural ash glaze and the warm reddish brown of the clay. *Height:* approx. 15.0 in.

17. Storage jar. Muromachi period. This classic jar is very well made with little evidence of the coil method apparent in the finished profile. The wheel marks at the shoulder and the flow of glaze accent the form's fullness. *Height:* approx. 15.8 in.

19. Storage jar. Muromachi period. A very compact form and well-turned neck and lip give this piece a dense inward feeling of latent strength. It is almost entirely enveloped in natural ash glaze of varying colors, which drapes over the form like a cape. Two distinct tiers of dripping glaze suggest that this piece may have been in an interrupted firing, the first part of which formed the lower coating of glaze while the upper coating was formed at a second period of high heat. *Height:* approx. 21.0 in.

52

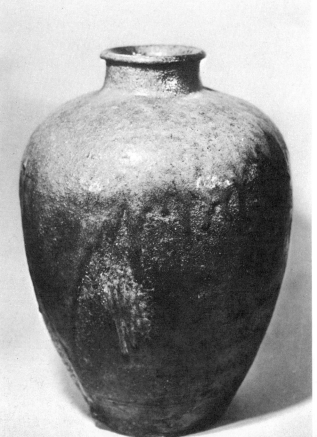

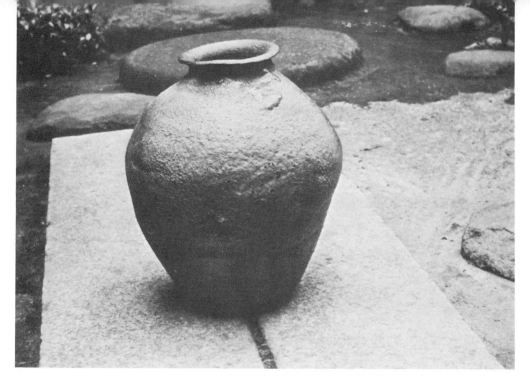

20. Storage jar. Muromachi period. The rounded irregular form of this piece suggests a water-worn stone. Its surface also has a stony quality. The ash glaze has not vitrified to the point of flowing and gives a rough-textured surface. The globule of glaze near the neck probably dripped on from another piece during firing. *Height:* 14.5 in.

21. Storage jar. Muromachi period. The concentrated form of this piece gives a powerful suggestion of volume. The use of coils is evidenced by the joints in the lower half of the jar which the potter did not quite smooth out. The entire surface is covered with a thin natural ash glaze. *Height:* 15.3 in.

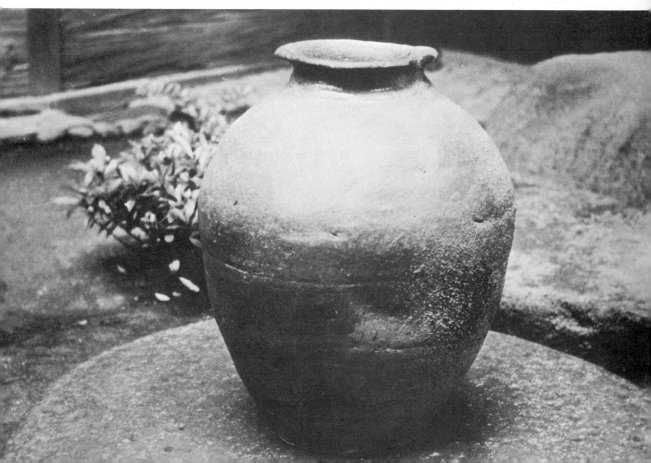

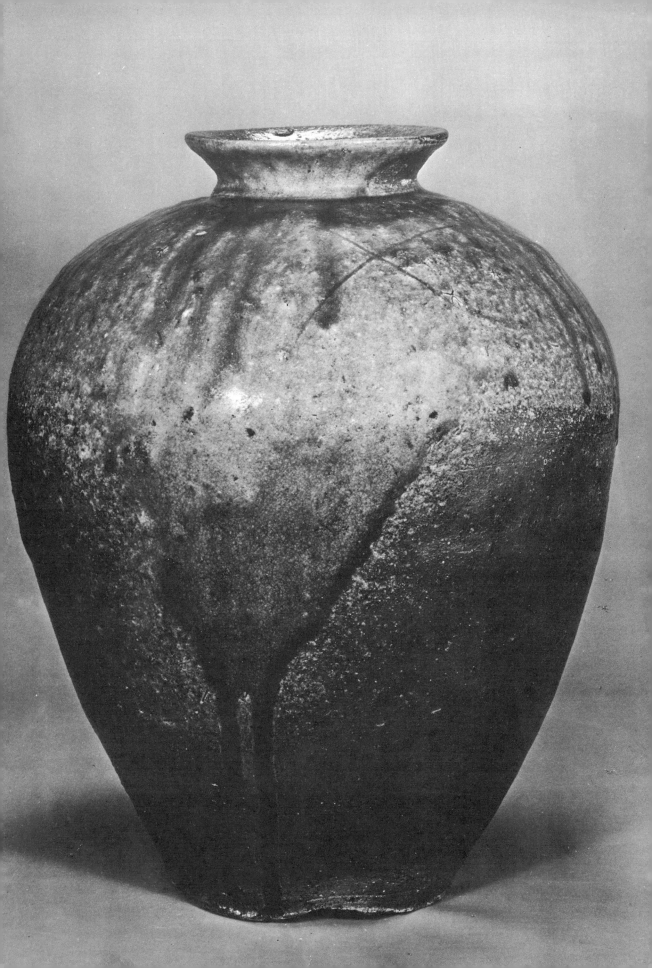

22. Storage jar. Muromachi period. This is one of the finest pieces outside of Japan. The natural ash glaze is a sea green; the clay varies from tan to brown. *Height:* 17.3 in.; Courtesy of the Smithsonian Institution, Freer Gallery of Art, Washington

23. Storage jar. Muromachi period. This beautifully made jar has a rich swelling form and well-turned neck and lip. The colors of the body and the glaze give a lively mingling of warm and cool hues. *Height:* 15.5 in.; *Collection:* City Art Museum of St. Louis

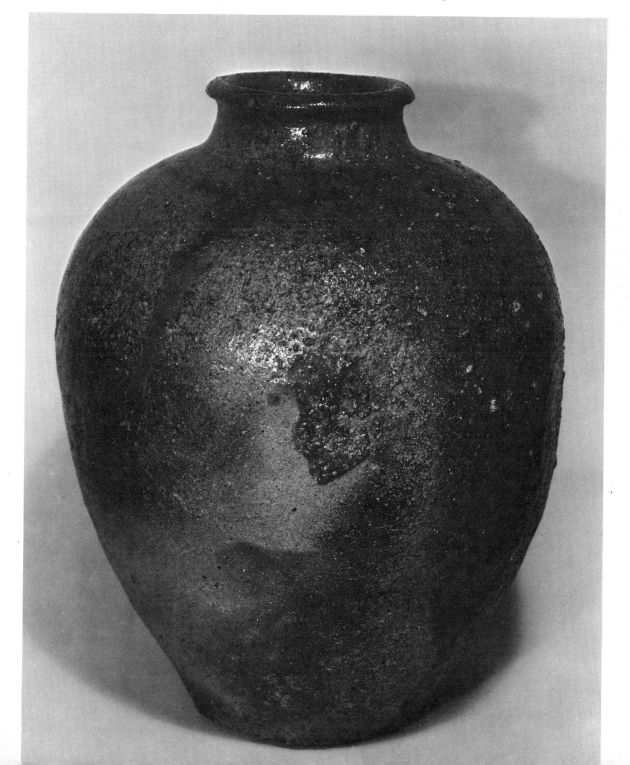

THE MOMOYAMA AND
EDO PERIODS

NOTABLE CHANGES occurred in the Tamba kilns during the
Momoyama period (1573–1614) and the early years of the
Edo period (1615–1868). This short phase of Japanese history,
during which the country was finally pacified and unified for
the first time, brought great social, economic and cultural
changes. Although the age was marked by tremendous upheaval,
bloodshed and destruction, the arts paradoxically flourished,
and in a sense the Japanese seem to have found their true
cultural expression at the very time when the nation was
experiencing the shock of the redistribution of power and
change of direction of the old feudal system. A new vitality
appeared in all the arts. The tea ceremony developed from
what had been essentially a monastic rite into an art form.
Activity in pottery increased, and Japanese ceramics were
given an infusion of life by the importation of Korean potters,
who were brought back after the ill-fated invasion of Korea.

At Tamba, the ceramic production which had gone on
virtually unchanged for generations experienced sudden growth
and development. The wars between fiefs, widespread and

almost incessant, brought with them a greatly increased inter-change between the different regions of Japan. This interchange mostly had to do with the warring factions contesting for power and authority, but at the same time, provincial boundaries· became more easily passable, and goods and people could some-times traverse boundaries which before had been blocked by tariffs and restrictions. Centuries-old feudal power gave way to bold usurpers, and conservative forces everywhere were weakened. It is certain that the more remote places like Tamba gained a new awareness of the outer world and a new identity as part of a nation. And with a more fluid exchange of persons and ideas, new techniques and ways of doing things developed. The old cave kilns were abandoned, and the potters built new ones on the slopes just above the valley floor. Production increased, new forms were introduced, and a more sophisti-cated technique developed, including the use of glazes.

As in other pottery making centers in Japan, the arrival of Korean potters during this period stimulated improvements in technique. The captive Korean potters revamped the rela-tively backward Japanese methods. In northern Kyushu they established a distinct style of pottery, Karatsu, which was actually a continuation of Korean Yi dynasty (1392–1910) stoneware. Most important, in the same area they introduced the manufacture of porcelain, which brought pottery in Japan to a level more nearly approaching the vastly more sophisticated methods then in use in Korea and China. In Kyushu some groups of Korean pottery workers maintained their cohesive culture for generations, and among potters in other localities remnants of the Korean language have even persisted down to modern times. It is not known whether Korean potters actually came to Tamba, or whether their influence was indirect. However, the abrupt changes which occurred in technique, and especially in kiln construction, seem to suggest that some

Korean potters were in fact present. But in any case, the presence of Koreans seems to have made no lasting cultural change in the life of the villagers. In all probability, the number of Korean immigrants into Tamba was very small, but sufficient to make an impact on the ways of the pottery shops. The kilns entered a new phase, and a direction was established which was to last almost to the present day. The design and construction of the kilns was improved, glazing was introduced, and pottery was made in larger quantity and more varied forms.

In some of the southern provinces, the feudal lords took a great interest in pottery and developed it as a competitive item of trade. This patronage was especially important in the rapid development of porcelain in the Arita (Imari) region. But the rulers of Tamba apparently did not take any interest in the potteries, perhaps because the shops were geared to the local agricultural market only. Thus, although Korean influence resulted in improved techniques, the Tamba potteries remained relatively obscure and small. The shops at Tachikui and the other villages took no part in the development of porcelain, and continued to make modest, traditional stoneware shapes. This obscurity, if you will, backwardness, made for a considerable degree of continuity at Tamba between the Muromachi period and the productions of the Edo period.

The new kilns appeared in about 1600. They were essentially the Korean style "split bamboo" kiln, built on the slopes just above the rice paddies. The shape resembles a split bamboo pole, a long tube partially buried in the earth. The angle of slope was sharp, about thirty degrees, and no divisions were built into the kiln to form separate chambers. Inside, the kilns were about four feet across, three feet high and more than one hundred feet long. This is considerably smaller than present-day Korean kilns of the same type. No more than about a third of the kiln rose above the level of the ground. Fuel was

introduced at the mouth of the tube, and through small holes in the sides of the kiln. The potters loaded the kiln by crawling through the mouth or through the upper end. Whereas the earlier cave kilns had been constructed by merely hollowing out a cavity in a bank or hillside, the kilns introduced during the Momoyama period were built of brick, and the structure was completed at the top with a self-supporting arch.

The new Korean-style kiln had several important advantages over the earlier cave kilns. The old cave kiln was limited in size, while the new kilns, although rather small in cross section, could be made very capacious by extending the length. They were built largely above ground and could be kept dry by the addition of a sheltering roof. Heat distribution was greatly improved by introducing wood through the sides of the kiln at various points as well as at the main fire mouth. Efficiency in fuel utilization was improved, a very important factor for potters who must cut or buy wood.

The quantity and uniformity of Tamba pots greatly improved with the advent of better kilns. But perhaps something was lost in the color and texture of the fired clay. From our point of view, at least, the older Tamba ware has a more interesting surface, largely as a result of the uncertainties of the fire. After the advent of Korean-inspired improvements in techniques and firing, Tamba pottery became more regular in shape, showed less fire flashing and natural glazing, and had fewer evidences of kiln accidents in the form of crumbs of refractory material stuck in the glaze or of warping. The natural deposit of ash glaze was greatly diminished by the shorter firing cycle which was made possible by the more efficient kiln.

About the same time as the change in firing methods took place, and also no doubt as a result of Korean tutelage, applied glazes came into use. It is a little hard to understand why glazing was so slow to appear at Tamba and other rural kilns. The

potters had long been familiar with the effects of ash on the pots, and with the fact that frequently a pot which had collected a considerable quantity of ash deposit during firing would come from the kiln almost completely covered with glaze. It would seem just a short step to proceed from that knowledge to the idea of mixing up ash or a mixture of ash and clay into a paste and putting that on the pot before setting it in the kiln. But the force of tradition seems to have inhibited any such bold experiment for several hundred years. What may have been missing is the idea of a smoothly glazed pot, something towards which the early Tamba potters were not striving. Their pots were already vitreous and waterproof and required no glaze to function well.

The earliest Tamba glazes were of three types: a black (Pl. 3), a reddish brown (Pl. 3), and an amber (Pl. 4). The black glaze was compounded of a mixture of some local clay high in iron content and of ash, most likely the pine and cypress ash collected from the kiln firing. A blend of about three parts of clay to one part of ash, fired to 1250° C. will give a similar effect. Depending on the firing conditions, the Tamba black glaze varied from a smooth, shiny, lacquer-like surface to a rougher leathery texture, sometimes greenish in color. The latter effect resulted from lower firing temperature. The reddish glaze was compounded from another clay, also blended with ash. The clay for the red glaze came from the village of Kitatani. This red-glazed Tamba ware is known as *akadobe*. The amber glaze was probably a straight ash and water mixture, and fired from a dull, grayish brown to a glowing, translucent amber. This amber color often flows in a winding, meshlike pattern (Pl. 4) in early Edo period pieces; though this ash glaze has been used to the present day, only recently has this effect been reproduced (Pl. 5). For many years, well into the Edo period, these three glazes were the only ones used in

Tamba. Of course there was considerable variation resulting from firing conditions and application. A bluish color (Pl. 3) is common, but this is the result of the heavy reduction of the black glaze, not of a different glaze composition.

The deposit of ash during firing continued to have an effect on the glazes, but this became less and less prominent as the firing cycle was shortened. Additional ash on the shoulders of pieces glazed with the black glaze often produced brownish or tan mottling (Pl. 30) and on the red glaze the effect of the ash was sometimes a variety of brown or black markings (Pl. 42). Heavy deposits of ash caused the applied glazes to drip or run downward on the pots.

For generations, the use of glaze at Tamba was very simple and straightforward, and little or no attempt was made to develop decorative processes. Pots were glazed either black, red or amber, or they were first glazed red, and the black or amber was applied over the red in areas (Pl. 4). Pieces were once-fired, and the glazes were applied on the leather-hard or dry clay.

Some time after the introduction of glazes at Tamba during the Momoyama period, the "drip" style of glaze application was developed. This technique, in which the glaze is poured freely over the pot to produce a fluid, flowing pattern is called nagashi-gaki (Pl. 44). There is little precedent for this kind of decorative effect in either Chinese or Korean pottery, and it must be credited as an original Japanese idea. Certainly the Japanese, beginning about 1600 and continuing down to the present, have developed the technique into many beautiful examples. Poured effects are achieved by filling a small bamboo dipper with glaze and cascading it against the side of a pot. The resulting pattern, while it seems entirely accidental and out of conscious control, may nevertheless be fairly predictable in form. The Japanese developed drip and pour patterns which

were repeated, at least to the extent of being recognizable. For example, a double flow over the side of a pot, dividing and running into two points is called the "hairpin." Another pattern, called "three hills," features three rounded accents, with glaze dripping down below them. Another, "crisscross," is formed of drips or trails of glaze put on at an angle and crossing over each other. These patterns combine a remarkable feeling of fluidity and ease with just enough structure and geometry to function as an integral part of the form upon which they appear.

Perhaps the technique of forming patterns from the flow of glaze originated as a way of compensating for the loss of the more accidental natural glaze effects of an earlier time. More likely it was the simple outgrowth of shop methods. Workers with a shop full of pots to glaze, and a tub of glaze on hand, may simply have let themselves go and allowed the materials to speak. In any case, such fluid, offhand surface effects proved to be very popular and became an important stylistic feature of Japanese pottery. We are confronted here with "action art" more than three hundred years old. There seems to be no parallel in Western ceramic art. In all the long history of ceramics in the West, the potter has been more in the position of one who carefully directs and controls the processes of his craft, rather than one who collaborates with the raw materials in the directions in which they seem to naturally tend. There is a fundamental difference between the two approaches. In one the potter stands above his materials and works his will on them; in the other he accepts the materials and the process as his partner. In Europe, the latter approach prevailed only in certain relatively crude folkcrafts.

The drip and pour glaze application was a natural and easy process. It went quickly and involved no great skill or precision. Until recently in Western art, such processes, involving a considerable element of the accidental, were ignored or

scorned as lacking depth, meaning, or design. Only in the mid-twentieth century have we come to realize that process and result can be as one, that the artist may identify with his work physically and kinetically as well as intellectually, and that a relaxed and immediate enactment in painting, in calligraphy, in poetry, in the dance, and even in music and theater can open the door to possibilities lying somewhere between the creator and his media, possibilities that can be reached for only with means other than the mind. Certain old Japanese pots powerfully and unforgettably demonstrate the potential of the direct and nonconscious union of action and material.

The Japanese have a healthy respect for "acts of God," for natural process. They revere the features of the landscape—mountains, rivers, forests. They have a keen appreciation for certain stones, and for the shapes of trees and shrubs. This regard is no doubt related to their idea of *kami*, the spirit or spiritual quality which may infuse places, natural features and common objects, both animate and inanimate. Kiln firing in Japan has always been regarded as something of a natural process, and the action of the kiln accepted much as the geologic processes of the earth are accepted for their results. What we might regard as accident is thought of more as natural happening, to be appreciated on its own terms rather than in relation to any set standard. The pot may have its *kami*, embodied as the sum of all the events that have shaped it. And the pot may be considered not so much a static object as a record of the play of various forces.

Another factor that favored the development of "action" potting in Japan was an attitude toward craftsmanship, still very much in evidence even today, which tends to diminish the distinction between the object made and the process of making. Japanese craftsmen have a direct way of working in which the rhythms of work have a satisfaction that perhaps relates them

more to dance than to a dumb repetition of action for the purpose of mass production. Work—the rhythmic, meaningful action of throwing, shaping, and glazing—is important, just as important as the finished product. In this framework the possibility exists of spontaneous imprints of feeling on the product. The pour of glaze, never quite the same on any two pots, but always sympathetic with the form, gives a kinetic record of the potter's dance, of his rhythmic gesture towards the pot.

Along with the introduction of glazes and the technique of poured glaze patterns, new shapes appeared during the Momoyama period. Storage and water jars (Pls. 24, 26–30, 54) continued to be the main production of the kilns, but their shapes became more regular and symmetrical as a result of the improvement in wheel technique. Grater dishes and saké bottles (Pls. 42–44, 47, 49, 51) also were made more precisely and suffered less distortion in the firing. Tea jars (Pls. 31, 35) were made; these relate in shape to the storage jar, but have three or four small lugs attached to the shoulder, probably for use in tying on a lid. The manufacture of tea jars certainly indicates that the potters had broadened their market, because these jars were not used locally. Another new shape was the saké bottle designed for use on ships, the *funa tokkuri* (Pls. 4, 42, 52). This bottle has a very broad base designed to prevent it from tipping over when the boat rocks. This form, also called the "scallion" bottle (*rakkyō-dokkuri*) because of its resemblance to the shape of that vegetable, is further evidence that some Tamba wares were being sold in more distant markets. These marine saké bottles were not decorated, and it is probable that they were made in considerable quantity and were sold very cheaply.

During the Edo period, in spite of somewhat increased production and wider distribution, Tamba wares remained the

obscure product of a relatively remote and underpopulated province. Since ceramic production made great gains in other provinces, the position of Tamba relative to the other pottery centers declined drastically.

The changes in pottery making which occurred in Japan in the early Edo period were so great that it could almost be said that what went before was mere prelude. The production of pottery increased many times, especially in the Seto region. Whereas before, pottery had been in only limited use in agriculture and in the household, it became, in the Edo period, an important article of trade and was in daily use in every home. The emergence of porcelain manufacture in Kyushu gave to pottery making an importance and interest which it had not enjoyed before. The Japanese began to take pride in their own ceramic art.

The Edo period was generally a time of political stability, and a great increase in trade between provinces occurred. Tamba pottery, which had been sold only in small quantities in distant places, was now distributed more widely. The Tamba pieces which were sold in neighboring provinces were for the most part strictly utilitarian forms. The bulk of production continued to be water jars, seed jars, saké bottles, hibachis (Pls. 45, 58) and containers for tea and spices. But in spite of a somewhat expanded market, Tamba continued to be a community of farmer-potters, relatively unaffected by city tastes or the changing ways of life which attended the rise of the commercial classes. The geographic location of Tamba was not favorable for really large-scale ceramic production such as that of Seto. Also, the local resources in clay and other raw materials were limited.

During the first decades of the seventeenth century, the effect of the tea ceremony was felt to some extent at Tamba. It was at this time that the tea masters, searching for utensils

which would embody their aesthetic ideals of naturalness, simplicity, and quiet restraint, turned to the rustic productions of the Japanese rural potteries. The vases and jars of Bizen, especially, were adopted with enthusiasm by the devotees of the tea cult. It was at this time that Furuta Oribe visited the pottery districts in Mino, near Seto, and established the distinctive style which bears his name. Here, and at Iga, the actual form of the pottery and its glaze treatment seems to have been determined by the impact of the sophisticated ideas of men who were not potters but functioned rather as arbiters of taste. In the case of Tamba pottery, the actual forms seem to have been scarcely affected by such outside influence, even though certain individual Tamba pieces gained fame as tea utensils. It is known that Kobori Enshū, a famous tea master, visited Tamba and ordered tea caddies to be made. One Tamba tea caddy known to have been used by Enshū is famous in Japan.

Technically, the Tamba pottery shops made significant advances during the Edo period. The kilns, now rebuilt on the near slopes of the valley just above the rice fields, were shortened and were articulated into sections, each having its own entry door. The technique of firing was improved, and a shorter firing cycle was adopted. The kilns were protected with permanent sheds, roofed over with cypress bark, and split dry wood was used for fuel, reducing the need for extended firing to attain the desired temperatures.

Storage jars, always the mainstay of the old rural potteries, continued to be made. On these the width of the mouths increased and the forms became more broad and squat. Production of saké bottles greatly increased, and the typical form became more graceful, with a taller and narrower neck (Pls. 63, 70), and these distinctive shapes, so unlike the product of other kilns, became widely known and associated with Tamba. Bottles for saké were supplied to brewers and distributors.

The name of the brewer or the trade name of the wine was commonly applied to the bottle as a slip decoration (Pl. 71). The slip was trailed on with a bamboo slip trailer operating by gravity (Pl. 122), and calligraphic designs of great fluidity and beauty were common on these Tamba pots. A source of white clay was found nearby for this white slip trailing. Later, pots were frequently coated entirely with white clay, often with decorations carried out in dark clay slips, either trailed on or dipped over the white.

One Tamba pottery shape that became widely known through distribution to various parts of Japan during the Edo period was the distinctive jar (Pl. 41) made to hold the spice *sansho*, a spice which was and still is produced in the province of Tamba. The *sansho* jars are either hexagonal or round, and the brand name of the spice is stamped into the clay in a panel on one side. Production of these *sansho* jars ceased sometime before the close of the Edo period.

A charming and distinctive piece of the period is the "fish" jar (Pls. 34, 57). The design, incised into the soft clay of a wide-mouthed jar, vividly suggests the scales of the fish. Another distinctive design was the leaf resist (Pls. 46, 51, 62), in which a leaf was attached to the side of the pot and slip glaze applied over it. When the leaf was pulled away, a silhouette in realistic detail remained. There seems to be no precedent for this particular technique in Japanese pottery, although the method was used by Chinese potters. There is a legend at Tamba that this decorative technique originated in an accident in which bamboo leaves were blown through the kiln with the fire, alighting on the shoulders of the pots and leaving a print, but of course this is fanciful. The leaf resist method was discontinued over one hundred years ago.

Kitchen and farmyard pots continued to be the mainstay of production at Tamba throughout the Edo period. Saké bottles

were made in great quantity, and a square-shouldered shape (Pl. 60) was developed, perhaps because it was an easier shape to make than the previous long-necked bottle. To produce the square-shouldered bottle, the bottom part was first thrown, then removed from the wheel and allowed to dry slightly. A coil of clay was later added, and the upper part was completed on the wheel. This seemingly rather involved process for making a small bottle was actually quicker and easier than throwing the shape from one lump of clay, given the rather nonplastic quality of the available material.

Production of grater bowls continued. The design remained essentially the same as the bowls made in the Muromachi period. Another staple item which was continued with little change was a squat little pot (Pl. 50), sometimes with a small spout, which was used to contain dye used by women to blacken the teeth, a cosmetic practice which has fortunately long since been abandoned.

Toward the end of the Edo period, a distinctive slip-decorated ware was made at Tamba. These slip pieces have an elegance and exactitude of technique that is somewhat untypical of Tamba wares in general. Quite common is the saké bottle made from brown clay and decorated with very precisely controlled bands of white slip under a clear glaze (Pls. 63). Decoration ''painted'' with a bamboo tube also appeared at this time (Pl. 70). Another style of slip-decorated saké bottle has a shrimp painted on one side (Pl. 65), usually in black and white slip over the gray or tan body. The skillful, almost suave quality of these designs suggests that perhaps the method and the design did not originate at Tamba. Perhaps itinerate potters from Kyoto or some other locality were responsible. These decorated saké bottles were possibly made in an attempt to develop a market in Kyoto and Osaka. The use of these decorative and rather highly developed slip

techniques mysteriously died out at the end of the Edo period.

One of the most interesting slip techniques at Tamba was called *sumi-nagashi* (Pls. 67, 68). The leather-hard piece was coated over with a white slip by dipping, and while the surface was still wet, a blob of black slip was applied. The piece was then shaken or jerked to give an accidental flow and shape to the black area. The character of this slip technique is somewhat related to the marbled patterns achieved by printing papers from ink floated on water, a method which, incidentally, has been raised to the status of an art by Japanese paper makers. In these Tamba "slip-shaken" wares the accidental effect was consciously sought after and put to good use. A clear glaze was used over the slips. The quality of the glaze indicates that feldspar was perhaps present as an ingredient, a material which may have been imported from some other province.

While certain Tamba pieces, such as the slip wares mentioned above, necessitated the use of refined materials, the bulk of production continued to be made of the coarse, relatively nonplastic local clays glazed with local slip glazes and ash. The limited extent of the local materials no doubt was one of the factors which prevented the Tamba potters from extending their range of form, color and texture. Difficulties of transportation inhibited the exchange of materials from one province to another. Even today, potteries in various localities in Japan are largely dependent on local clays and do not exchange clay with other parts of the country. At Tamba, as in other pottey centers in Japan, this reliance on the local materials, limited as they were, was a source of strength. The potters, concerned with few variables, learned to make the most of these limitations.

Compared to the noble and universal quality of the old Tamba jars, the works of the Edo period may seem relatively mudane and pedestrian. The greater diversity of technique

and form did not bring with it any notable aesthetic advance. In these later productions of Tamba an unevenness appears. The majority of pieces are rather heavy and dark in color, and while they have the sturdy virtues of good functional form and straightforward potting, they have lost some quality, hard to locate explicitly, which seems present in the majority of earlier pots. A few pieces stand out—those in which form and glaze come together in a particularly harmonious way. In earlier times, although variety was severely limited, all the pieces seemed to be more on the same level of excellence. But even granting that the best period of Tamba pottery was during the Kamakura, Muromachi and the Momoyama periods, a considerable measure of robust strength and beauty has been sustained with remarkable continuity through the many generations down to the present.

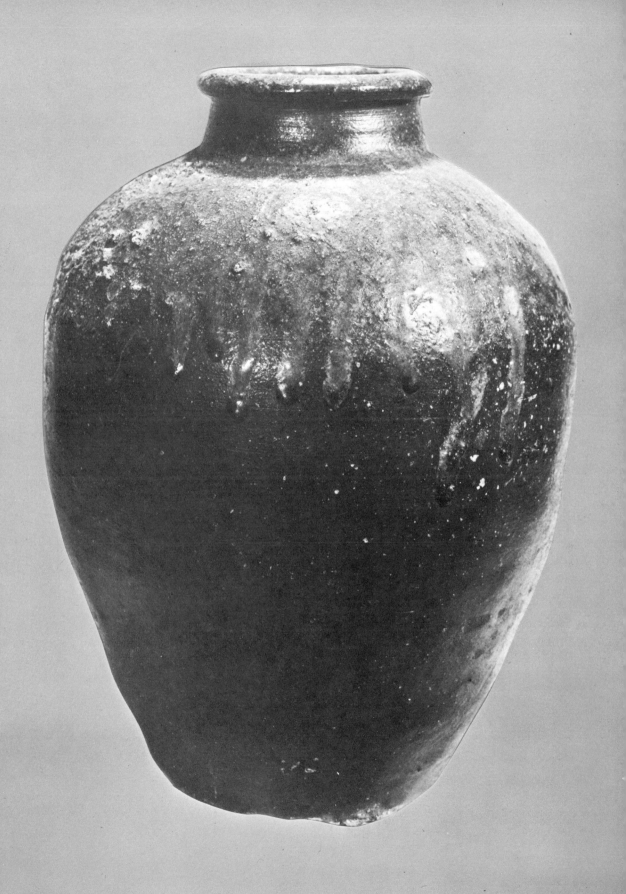

24. Storage jar (*previous page*). Momoyama period. The shoulder is coated with natural ash glaze and is encrusted with bits fallen from the kiln. *Height:* 13.3 in.; *Collection:* Dr. Roger Gerry

25. Hanging flower vase. Momoyama period. The metal ring on the shoulder of this charming tea ceremony vase is used in hanging the piece. The rich greenish natural ash glaze partly covers the dark brown clay. *Height:* 4.5 in.; *Collection:* Victor Hauge

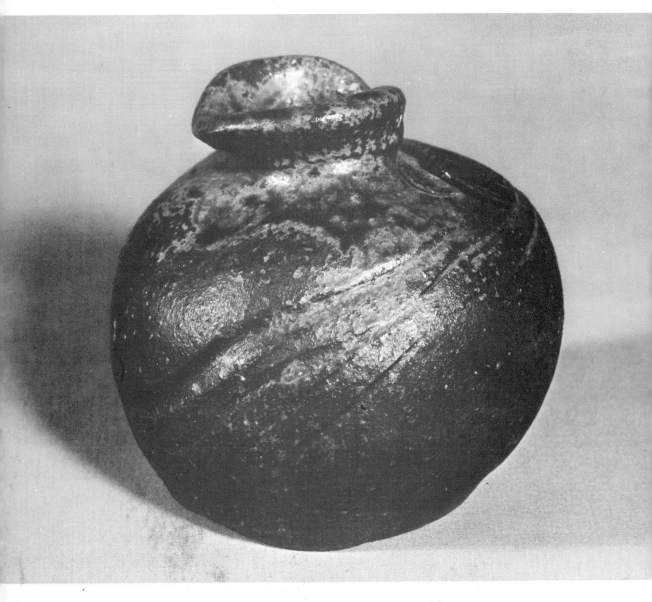

26. Storage jar. Momoyama period. This smoothly
potted jar is pure Tamba in style. The thick natural
ash glaze is green gray. *Height:* 17.5 in.; *Collection:*
Tamba Pottery Museum, Sasayama

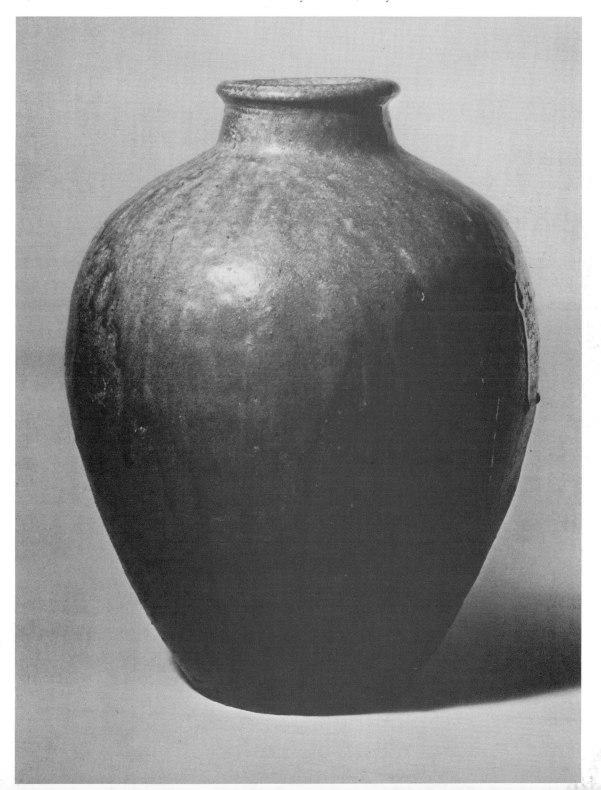

28. Storage jar. Momoyama period. Scars near the foot, such as that seen on this jar, were usually the result of breaking off the pad of clay used to keep the pot level on the sloping floor of the kiln. The scar on the left resulted from contact with another pot during the firing. *Height :* 14.4 in.

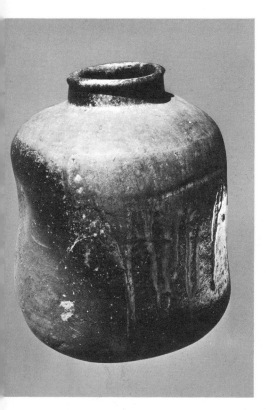

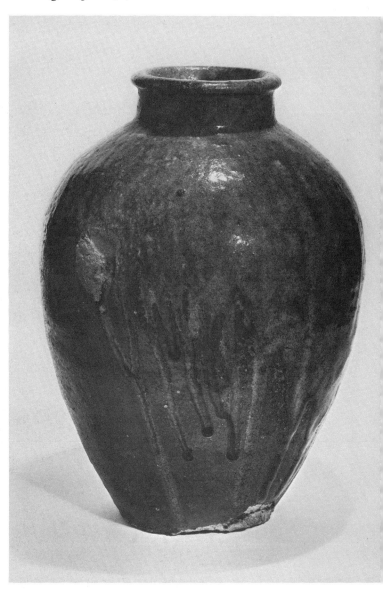

27. Storage jar. Momoyama period. The natural ash glaze is a warm tan color, and the clay body is burnt orange. The bulging shoulder, rather unusual in jars from this period at Tamba, and the rounded bottom give this piece a full, plastic quality. *Height :* approx. 12.0 in.

29. Storage jar. Momoyama period. The streaked ash glaze, amber in color, is one of the earliest types of applied glaze used at Tamba. The absence of flashing or natural ash glaze deposit on this piece indicates the changes in firing technique which had occurred by this time. *Height:* 16.1 in.; *Collection:* Tamba Pottery Museum, Sasayama

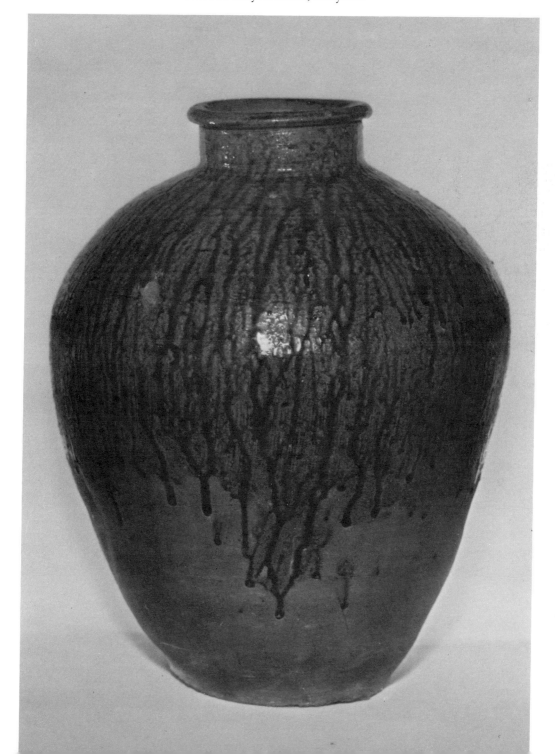

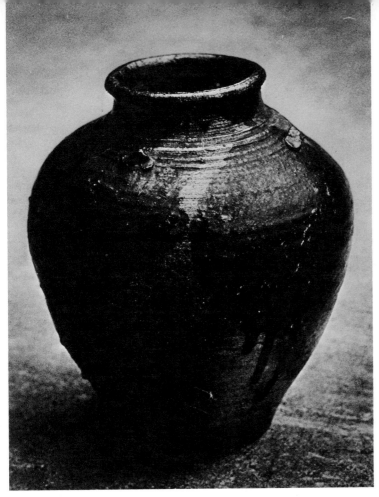

30. Storage jar. Momoyama or early Edo period. The dark greenish black glaze has been dipped on the pot in controlled areas, with some drip. The exposed clay is thinly coated with glaze from the kiln atmosphere. The lugs are pushed against the pot so as to leave no opening, and must have been considered decorative. The three stages of coil additions are clearly discernable. *Height:* 13.0 in.; *Collection:* the author

31. Tea jar. Momoyama period. The fingers of dripping glaze enclose the rich, full, distended form. Here the plainly visible termination of the first coil marks the beginning of the outward thrust of the belly of the pot. The lugs, originally serving to hold the string or thong which fastened on the lid, have no openings and are decorative in effect. The glaze is a warm beige. *Height:* 20.3 in.; *Collection:* Tamba Pottery Museum, Sasayama

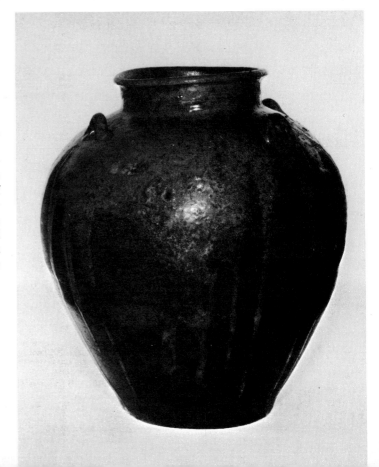

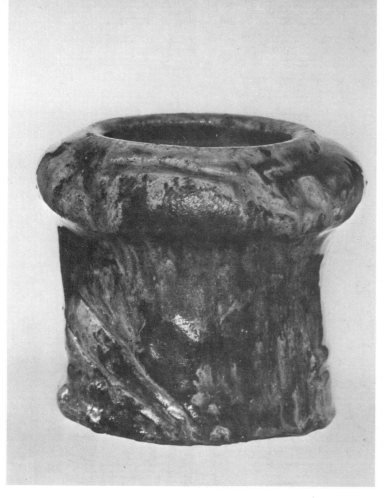

32. Tea ceremony water jar. Early Edo period. This small piece is not typical of any class of wares made at Tamba, and may have been produced at the request of some tea master. The glaze, running in streaks, is beige, blue, brown and white. The rubber tire-like top and the dents in the side may have been inspired by certain Bizen tea ceremony vases. *Height:* 5.9 in.; *Collection:* Tamba Pottery Museum, Sasayama

33. Tea ceremony vase. Momoyama or early Edo period. This is one of a small class of wares made for the tea ceremony at Tamba in the late Momoyama and early Edo periods. The throwing is quick and offhand, with some irregularities resulting from handling the soft piece. The lugs, which are not functional, give a rustic quality to the form. The glaze is dark brown with beige mottlings. *Height:* 9.4 in.; *Collection:* Tamba Pottery Museum, Sasayama

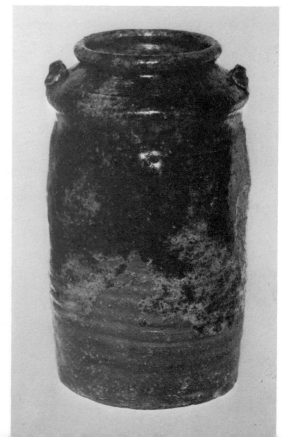

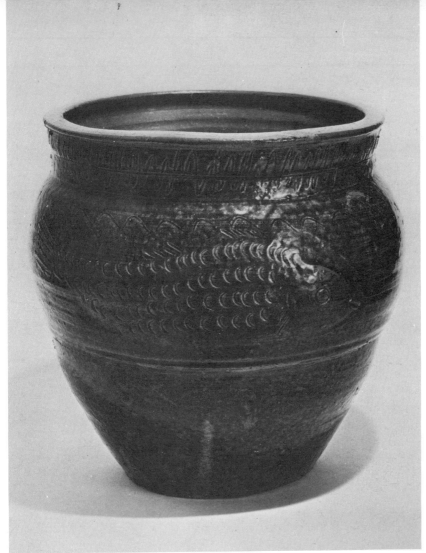

34. Jar. Early Edo period. The fish design is impressed into the soft clay, probably with a bamboo tool. These charming fish pots are distinctive to Tamba. The amber ash glaze over the freely executed pattern gives a fluid effect that is very suitable to the subject. *Height:* 11.6 in.; *Collection:* Tamba Pottery Museum, Sasayama

35. Tea jar. Early Edo period. Judging by the number of surviving examples, these tea jars used for the storage of tea in shops, must have been made in considerable quantity in Tamba. This jar is shaped with great authority and has a beautifully proportioned collar and lip. The streaked ash glaze is amber in color. *Height:* approx. 14.5 in.

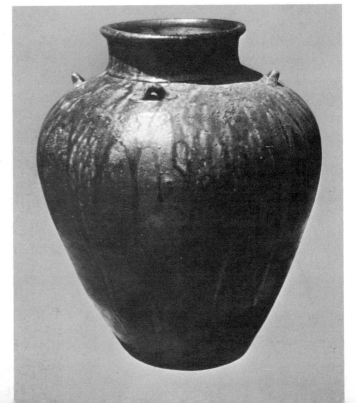

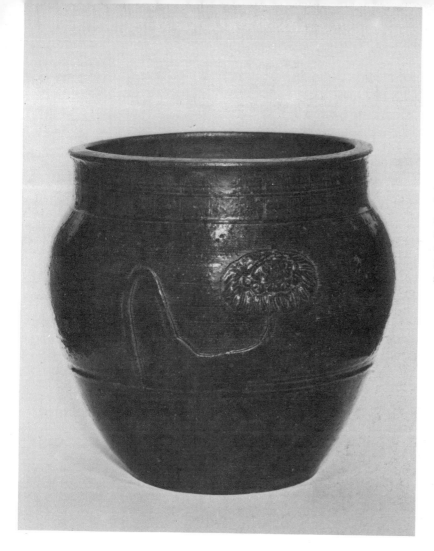

36. Jar. Early Edo period. With the advent of glazing in Tamba, there was an increase of interest in the decorative possibilities of clay surfaces. The flower design was made by applying a pad of soft clay to the surface and modeling it with a tool. *Height:* 15.8 in.; *Collection:* Tamba Pottery Museum, Sasayama

37. Jar. Early Edo period. Distorted jars of this type have survived in some quantity and must have been popular. The irregular shape is not the result of firing but was given to the soft clay. The textured ash glaze is brown. This distinctive and somewhat eccentric pot is peculiar to Tamba. *Height:* 11.0 in.

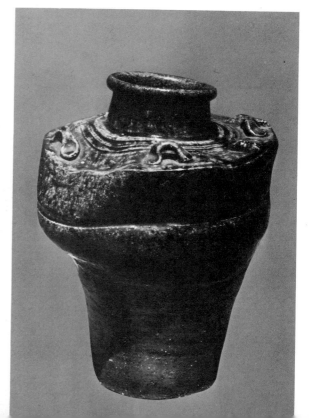

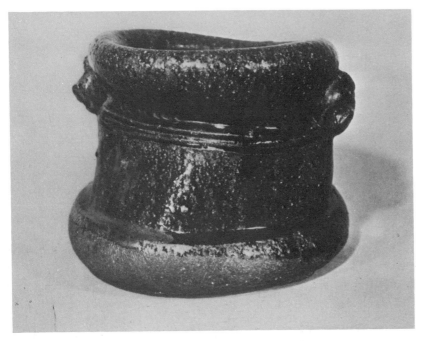

38. Tea ceremony water jar. Early Edo period. This charming jar is not typical of Tamba, but was probably made from some model furnished by the tea ceremony trade. The form is moving, restless and active, but the effect is nevertheless one of compact volume. In this and other Tamba tea wares the strength of earlier utilitarian wares is successfully infused into more specialized and sophisticated designs. *Height:* approx. 6.0 in.

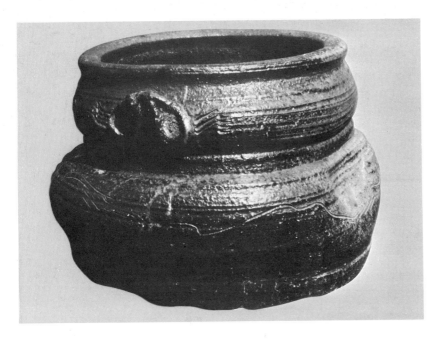

39. Tea ceremony water jar. Edo period. The mark of the wheel is strong on this rugged piece, which is glazed thinly with a red-brown slip glaze. In use, such a piece would be fitted with a lacquer lid. The application of the lugs and the incised marks is carried out with great verve. *Height:* 7.5 in.

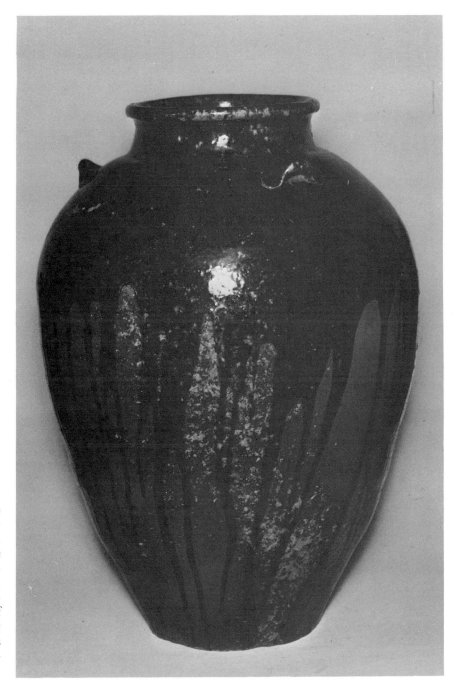

40. Tea jar. Early Edo period. Black glaze cascaded down over the red. Into this equation, the fire has thrown the addition of natural ash glaze, which softens and differentiates one side of the pot. *Height:* 21.5 in.; *Collection:* Tamba Pottery Museum, Sasayama

41. *Sansho* jar. Early Edo period. Hexagonal jars of this type were made at Tamba as containers for the spice *sansho*. The glaze is black. The blisters under the glaze, probably due to rapid firing, were not considered a serious enough flaw to prevent the use and preservation of the piece. *Height :* 11.0 in.

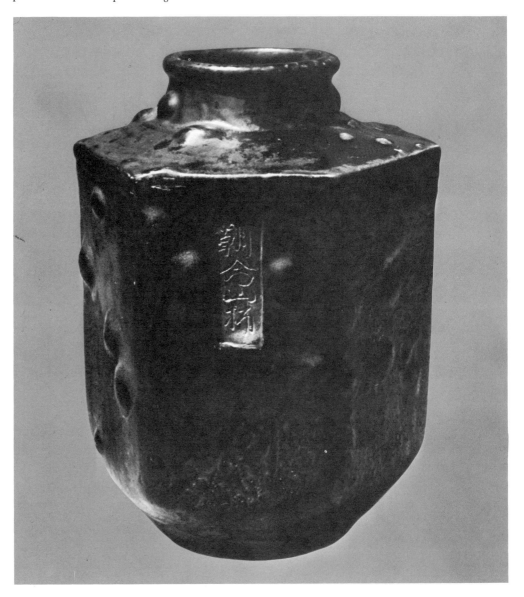

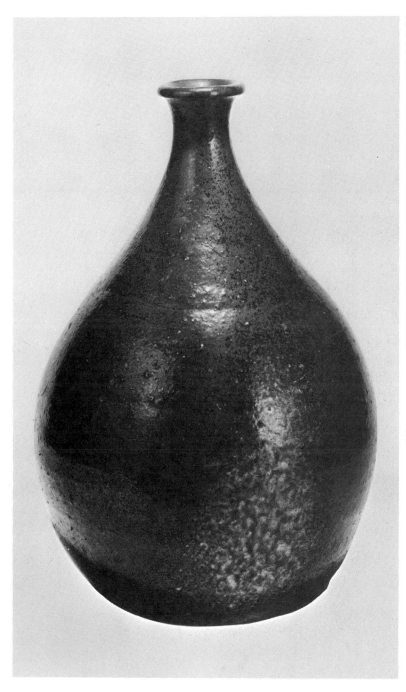

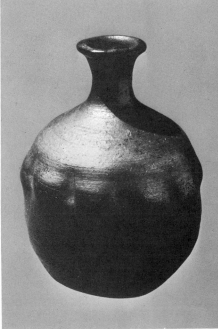

42. Saké bottle. Early Edo period. This is a *funa tokkuri*, a wide-bottomed saké bottle intended for use aboard ships. The bright red slip glaze is mottled by a deposit of ash on one side. The potter formed the neck of the bottle from a coil attached to the bottom part at a point clearly visible. *Height:* 13.2 in.; *Collection:* Tamba Pottery Museum, Sasayama

43. Saké bottle. Early Edo period. The rich undulation of form and the thin iron glaze give this piece an intense, tactile value. *Height:* 8.75 in.

83

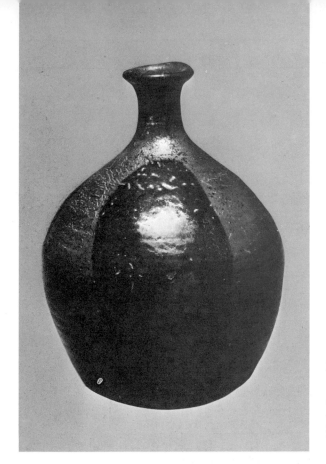

46. *Shōyu* jar. Early Edo period. The black ▶ glaze runs down over red-brown, which is also revealed by the small leaf resist. In use, a spiggot was put in the hole at the bottom of the jar to dispense the soy sauce (*shōyu*). The piece is signed Kichizaemon. *Height:* 13.6 in.; *Collection:* Tamba Pottery Museum, Sasayama

44. Saké bottle. Early Edo period. The red-brown glaze has crawled slightly from overly thick application. The poured black pattern is perfectly placed and amplifies the fat curves of the bottle. *Height:* 8.25 in.

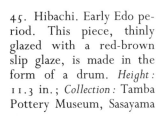

45. Hibachi. Early Edo period. This piece, thinly glazed with a red-brown slip glaze, is made in the form of a drum. *Height:* 11.3 in.; *Collection:* Tamba Pottery Museum, Sasayama

84

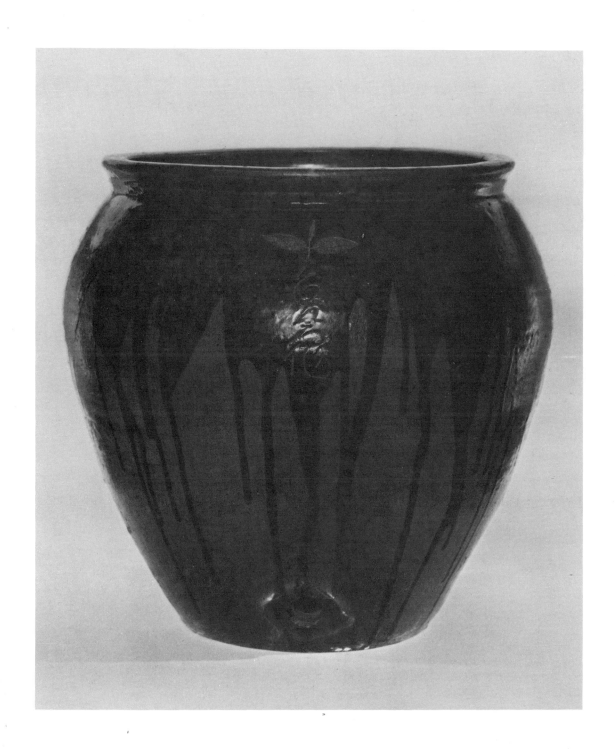

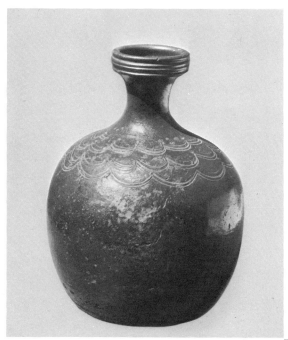

47. Saké bottle. Early Edo period. The precisely turned collar of this piece is rather unusual. The incising on the shoulder was done with a three-pronged comb, probably of bamboo. The glaze is dark brown with some influence from ash in the kiln. *Height:* 8.0 in.

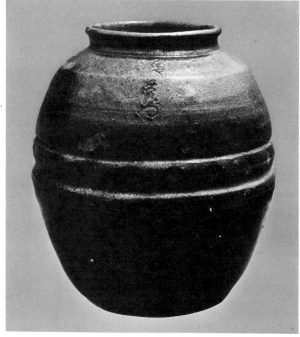

48. Storage jar. Early Edo period. In the Edo period, in contrast to the set forms of earlier times, numerous pieces were made which had features of a more experimental sort, such as the broad band around the middle of this pot. *Height:* approx. 16.0 in.

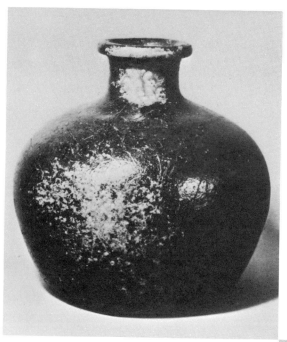

49. Saké bottle. Early Edo period. The red-brown glaze is mottled on one side by the influence of ash. *Height*: approx. 8.3 in.

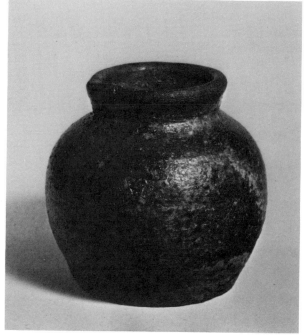

50. Pot for tooth dye (*ohaguro*). Early Edo period. These small, squat shapes with a suggestion of a pulled spout were used to hold the dye used by women for blackening the teeth. Brown ash glaze. *Height*: 3.8 in.; *Collection*: Tamba Pottery Museum, Sasayama

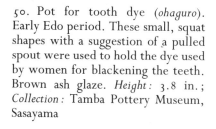

87

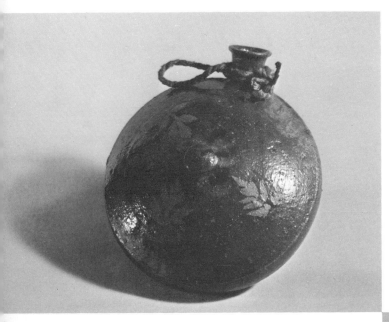

51. Hanging saké bottle. Early Edo period. Two bowl-shaped forms were combined to make this flat bottle, which perhaps was intended to hang from a saddle. It is thinly glazed in brown with a leaf resist pattern. *Diameter:* 7.7 in.; *Collection:* Tamba Pottery Museum, Sasayama

52. Saké bottle. Early Edo period. This large *funa tokkuri*, or saké bottle for use on ships, was thought until recently to be Bizen, and in fact its thinly glazed surface with an area of thicker natural ash glaze deposit is very similar to certain Bizen pieces. The precision of form of this large piece indicates a highly developed wheel technique. *Height:* 19.7 in.; *Collection:* Tamba Pottery Museum, Sasayama

88

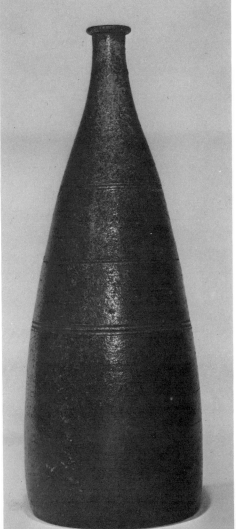

53. *Umeboshi* jars. Early Edo period. These charming jars were made to contain pickled plums. Appliqués in imitation of rope are common on such pieces. A capacity for playful handling of clay became evident at Tamba during the Edo period. *Heights:* 8.5; 8.2 in.; *Collection:* Tamba Pottery Museum, Sasayama

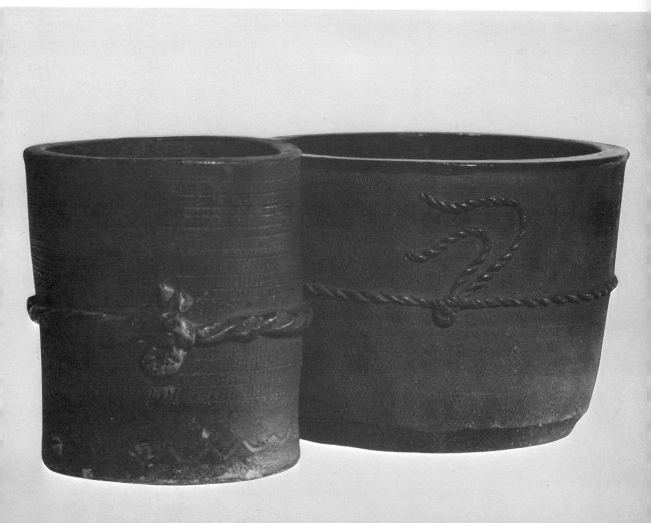

54. Storage jar. Momoyama or early Edo period.
This jar is unglazed and has received very little natural
ash glazing on its brown-gray surface. The form is
generous and full, amplified at the shoulder by the
graceful combing. *Height:* 14.5 in.

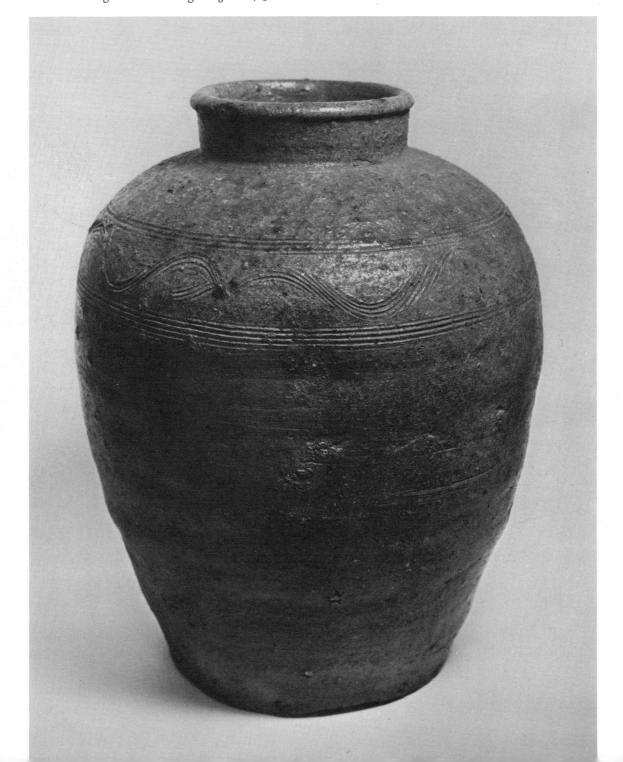

55. Buddhist altar vase. Middle Edo period. The elegant design was cut through the black slip glaze into the still soft clay, probably with a bamboo tool. *Height:* 6.5 in.; *Collection:* Tamba Pottery Museum, Sasayama

56. *Umeboshi* pot. Middle Edo period. This dark brown pickled plum jar has the rugged, forthright character typical of Tamba pots of all periods. *Height:* 8.6 in.; *Collection:* Tamba Pottery Museum, Sasayama

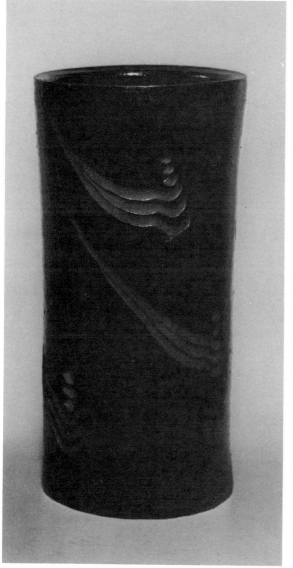

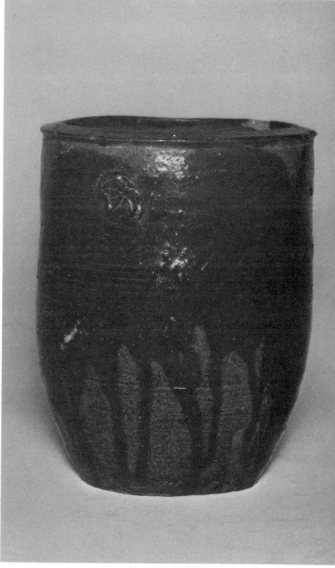

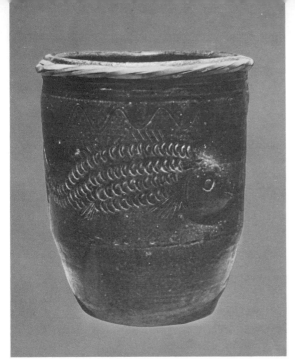

57. Jar with fish design. Middle Edo period. The braided bamboo collar was added to minimize the danger of breakage. *Height*: approx. 12.5 in.

58. Hibachi. Middle Edo period. A rather flamboyant piece with sprigged handles and floral designs, covered with a smooth, dark amber glaze. *Height*: 9.3 in.; *Collection*: Tamba Pottery Museum, Sasayama

59. Sprig molds and stamps. Early and middle Edo period. These molds and stamps are made of fired clay. The center leaf shape shows both a mold, above, and a hand-modeled positive from which a mold was made. The small pieces, bottom, left and right, are stamps. *Height of top left mold: 3.5 in.*

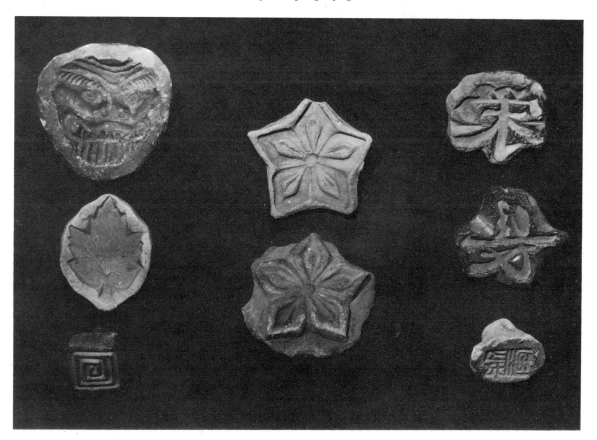

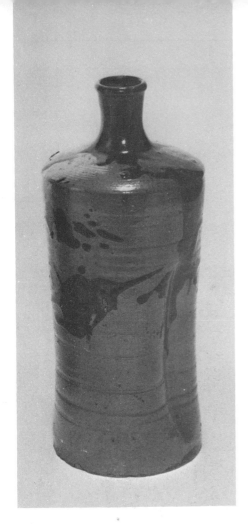

60. Saké bottle. Middle Edo period. This type of square-shouldered bottle is known as a *rōsoku* ("candle") *tokkuri*. This piece has a deeply squashed-in side and freely splashed black glaze over brown. *Height:* 8.9 in.; *Collection:* Tamba Pottery Museum, Sasayama

61. *Shōyu* pot. Middle Edo period. This rather thickly thrown piece has been paddled into a square shape. The glaze is a dark amber color. *Height:* 13.2 in.; *Collection:* Tamba Pottery Museum, Sasayama

94

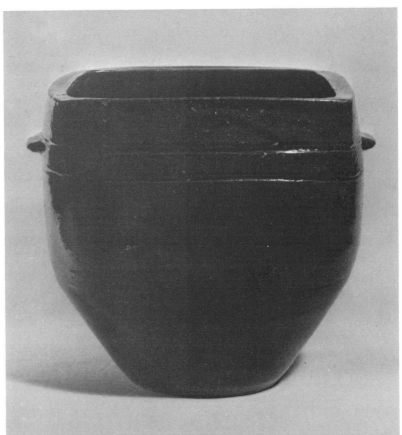

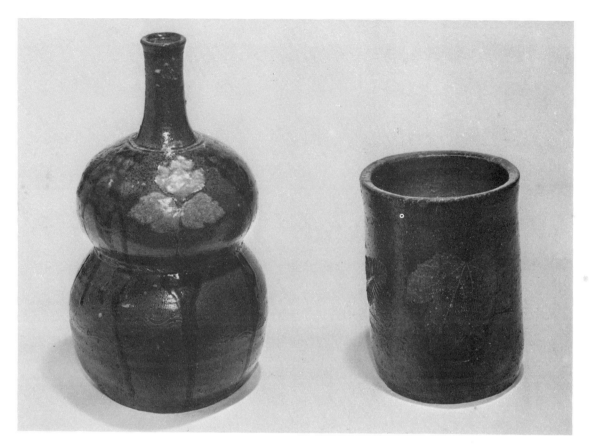

62. Leaf resist pots. Middle Edo period. On the gourd-shaped saké bottle at the left, the leaf impression has been filled in with light glaze. Note the modeled string at the constriction of the form. On the piece at the right, leaves were impressed into the soft surface just before the application of the slip glaze. This interesting decorative process seems to have been unique to Tamba. *Heights:* 9.3; 5.0 in.; *Collection:* Tamba Pottery Museum, Sasayama

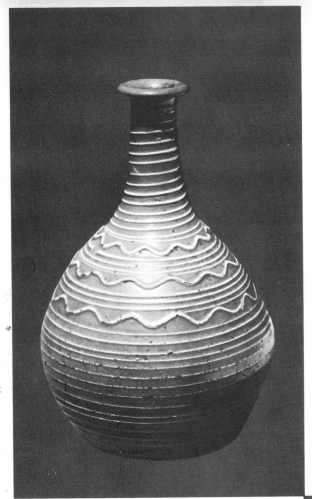

63. Saké bottle. Late Edo period. The banding in white slip over a light brown background is applied with great skill and gives a lightness and vibration of surface in keeping with the function of the piece. *Height:* 10.5 in.

64. Storage jar. Late Edo period. The full, globular form is embellished with innumerable spots of white slip applied with the fingertip, probably the work of some elderly lady assisting in the pottery shop. A spirit of playful experimentation is quite common in later Tamba pots. *Height:* 14.5 in.

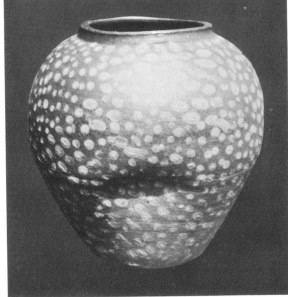

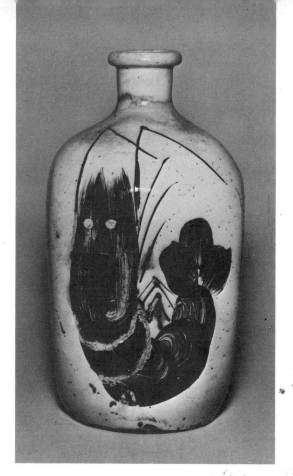

65. Saké bottle. Late Edo period. The decoration is painted in black slip over a white engobe which covers the entire surface. In this example the brushwork is sure and authoritative, giving body and life to the shrimp. Eyes and segment lines were cut through the black. *Height:* 9.1 in.; *Collection:* Tamba Pottery Museum, Sasayama

66. *Yutampo* (hot water bottle). Late Edo period. This piece, in the "rice bale" shape, is glazed dark greenish brown to black. *Length:* 11.5 in.; *Collection:* Victor Hauge

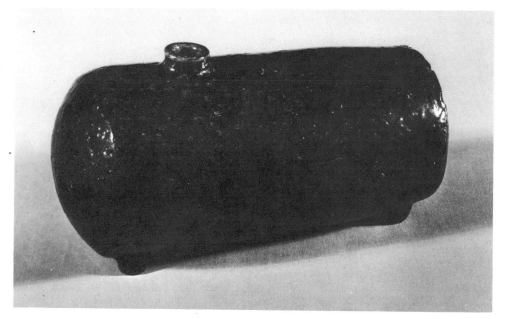

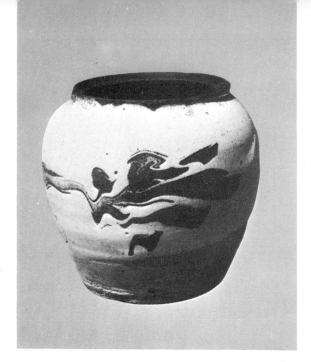

67. *Sumi-nagashi* jar. Late Edo period. In this *sumi-nagashi* technique, black slip is floated over wet white slip, giving an active, unpredictable configuration. The wavelike pattern here vitalizes the squat shape of the jar. *Height:* 5.5 in.

68. *Sumi-nagashi* saké bottle. Late Edo period. This finely shaped piece was gently paddled while soft to flatten the sides. The floating smoke-like black pattern gracefully ascends the wall, and seems to intensify the white ground color. *Height:* 8.7 in.; *Collection:* Tamba Pottery Museum, Sasayama

98

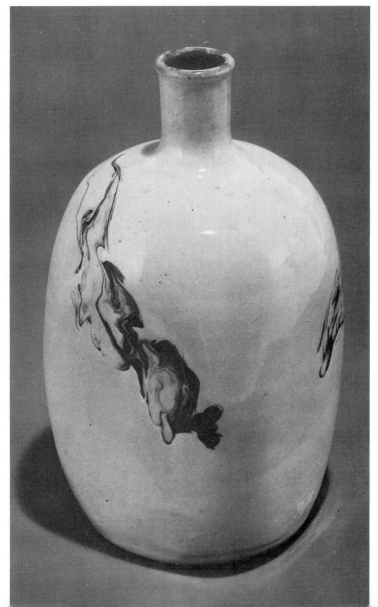

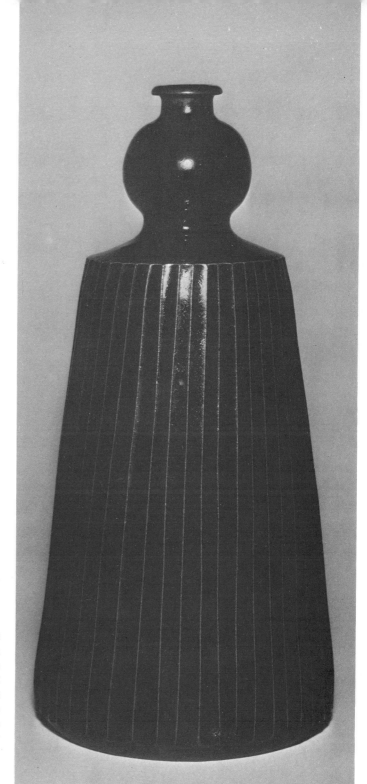

69. Saké bottle. Late Edo period. This *kasa-dokkuri*, or "umbrella saké bottle," is a good example of a certain elegance which appeared in some later Tamba pots. The black glaze has pulled off the ridges of the perfectly cut fluting. The name comes from the obvious resemblance to a folded Japanese oiled paper umbrella. *Height:* 9.4 in.; *Collection:* Tamba Pottery Museum, Sasayama

70. Saké bottles. Late Edo period. The art of slip trailing with the bamboo tube reached a high point in the late Edo period, as illustrated by these three bottles. The body color is buff, with white lines, which in the center and right hand pieces depict plum blossoms. *Heights:* 10.3; 8.8; 9.1 in.; *Collection:* Tamba Pottery Museum, Sasayama

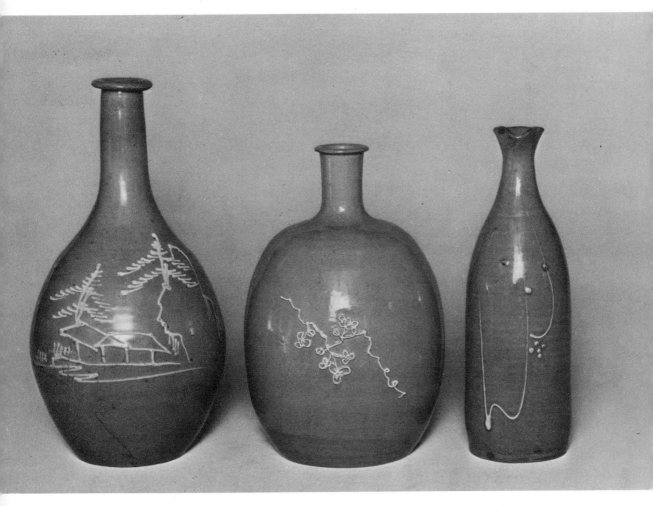

71. Saké bottles. Late Edo period. Thousands of saké bottles were produced at Tamba, many of them inscribed with the names of the brewers trailed either in white slip over the brown clay, or in black slip over a white engobe. On the example at the right the calligraphy was done by using a blunt tool to wipe away the wet slip glaze. The name of the saké on the white bottle may be roughly translated "Demon Toppler." *Heights*: 9.3; 6.8; 10.0; 9.1 in.; *Collection*: Tamba Pottery Museum, Sasayama

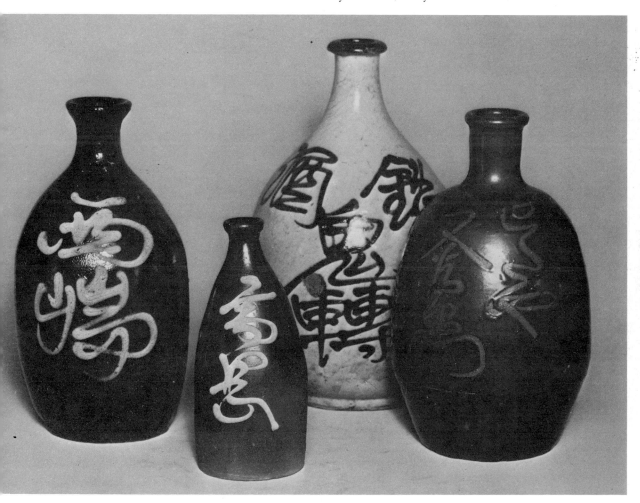

72. Saké bottle by Kayū. Late Edo period. This is one of a small number of Tamba pieces made by a craftsman whose name and style are known. The topknot is the bottle stopper, and the ladle, the spout. Transparent glaze over grayish tan body. *Height : 8.9 in. ; Collection :* Tamba Pottery Museum, Sasayama

TAMBA IN RECENT TIMES

OUR FIRST visit to the village of Tachikui was on a cold day in early March. We took the train from Kobe, leaving behind the endless urban sprawl of the Osaka plain. We wound up the gorge toward the mountains, following a wildly cascading stream. The train reached the sparse uplands, and after an hour's ride we reached the village of Arino where we got off at the little unpainted wooden station. The acrid smoke from the puffing ancient locomotive mingled with the clear sharp air. Then we boarded a muddy bus in which a few passengers sat thoughtfully, ready for the run to Tachikui. We settled down on the impossibly narrow seats, the bus-girl swung gracefully aboard, and the bus started jerkily through the village, hitting each bump with a sickening thud. A mile or so out of Arino the road seemed to virtually disappear between the rice fields and the dikes, and we hung onto our seats as the bus wallowed through the mud. Soon, on higher ground, the road improved, and we picked up speed as we began the steep climb to the east. Above the upland agricultural plain we came into an area of scrubby timber, passing only an occasional habitation. The

land seemed almost deserted. The road twisted upward, unmarked by sign or number. All aboard were now dozing except for the driver, the bus-girl, and ourselves. A half-hour's climb brought us to the summit of the ridge, and we caught a glimpse of the valley to the east. The bus began its descent through the low trees. With ten miles yet to go, the road was steadily deteriorating. We knew that off to our right as we wound downward were the ruins of the ancient kilns of the region. These mouldering caves, now filled with roots, are known only to a few local people and to the Japanese historians of pottery.

The road leveled off and we reached a Y, which is the bus stop for Tachikui. At the lower altitude it was a bit warmer, and the snow was melting in the pale morning sunshine. We walked toward the center of the village, still more than a mile away. Tachikui is much like a thousand other Japanese villages. It occupies its own small area of flat land, and is strung out east to west in a line of dwellings (Pl. 75). On one side are the fields and rice paddies and on the other is the steeply rising hillside leading to the low mountain slopes to the west. The road meanders through the village, paralleling the quiet river. The surrounding mountains are rather barren and forbidding, and on this morning they were covered with snow. Our destination, the shop of Mr. Hiroyuki Ichino and his older brother, was on the extreme opposite end of the village. As we threaded our way along the road, evidences of pottery activity were everywhere: piles of firewood, stacks of finished pots beside the houses and in sheds, and at intervals, the long kiln roofs, sloping upwards on the hill and behind the buildings which fronted the road. The small clay-settling ponds* near the road were filled with yellow mud. There is no center or "downtown"—only a little roadside shrine (Pl. 76) near the center of the village, which is set at the base of a hoary, seven-hundred-

year-old Zelkova tree. A bit further on there was a small store selling groceries, saké and sundries, which were displayed in a grimy window. Sheds and buildings closely line the road, all splashed with yellow mud from passing vehicles.

The village is quiet, serene, all-of-a-piece architecturally, and beautiful in its relation to the sloping ridge behind and the flat fields below, which form a jigsaw puzzle design marked by the low mounds controlling the irrigation. The visual unity of the village and its look of having grown slowly and naturally from the earth is in perfect keeping with the wholeness and organic quality of Tamba pottery. A modest *torii* stands at the beginning of a meandering path out across the fields to the Tachikui shrine, which is hidden from view by a grove of cypress trees. As we looked back at the row of dwellings and shops, black smoke rolled up from the rear of one of the long kiln sheds, indicating that a firing was in progress.

We reached Mr. Ichino's pottery, a large barnlike structure, with clay-drying tanks in the front yard.* Just outside the door were rows of large pots drying in the sunshine. The potters had evidently been at work since early morning. We stepped inside to rather dark interior space filled with smoke from a small fire in the middle of the dirt floor, at which three workmen were warming themselves. We learned that Mr. Ichino would return shortly, and as our eyes became accustomed to the dim light we studied the room. At one end was a large mound of plastic clay which was not covered—presumably the clay was used up before it had a chance to dry out. The entire interior (except for the beamed ceiling blackened by soot) was covered with dried yellow-gray clay, and the floor was of the same color. Spatters of clay also obscured the few small windows. A jigger wheel and a pug mill were run by belts from the same motor. Near the entrance were two potter's wheels. Numerous molds and bats were piled against the wall at the back

of the room, and racks held quantities of dry pots. A rickety ladder led to the loft above. We squatted on the smooth dirt outside the door and ate our lunch: *obento* (boxed lunches) brought from the city. We studied the kilns, a large Tamba kiln across the road and a smaller updraft bisque kiln and observed the forms of the numerous pots drying in the yard.

Riding his motorbike, Mr. Ichino returned, weaving his way skillfully down the road through the puddles. Our visit had been prearranged by letter, and he was expecting us. After introductions, he excused himself and work began again in the shop. The men started the jigger machine, and the production of large planters was punctuated by the steady knocking and flapping sound of the belts. Each completed piece in its mold was carried to the yard to dry, and on the return trip a leather-hard piece was brought in, turned out of the mold, 'and trimmed. Mr. Ichino had been making saké bottles, and he now returned to his wheel. Earlier he had made the bottom parts of the bottles, simple cylinders, each still stuck to the little wooden platform on which it was made. He now centered the pot again on the wheel and applied a little rope of fresh clay at the top edge. This he quickly formed into the shoulder and neck. Each bottle was completed in about one minute's time, but in spite of this rather rapid rate of production Mr. Ichino seemed to be perfectly relaxed and deliberate in all his motions, and his lighting and smoking innumerable cigarettes did not seem to interfere in the least with the work.

When several pallet boards crowded with bottles were completed, we left the shop to visit Mr. Ichino's brother and to see their collection of old Tamba pieces. We walked back up the road to a pleasant house, quite new, which was not connected with any pottery shop or kiln. There we were greeted by Mr. Ichino's brother, a somewhat older man, not dressed for work. We removed our shoes on the concrete floor

of the entranceway and went into the chilly main room of the house, where we settled down on pillows on the soft tatami floor. About forty pots were on the floor, and our hosts passed each one along, introducing it with a short commentary. I felt a little disappointed in the pots, and could not help comparing them unfavorably to certain Tamba pieces I had seen in the Kyoto National Museum. But they were authentic pieces, each having the unmistakable style of Tamba, a style distinct from that of any other Japanese pottery. Tea was brought in by an anonymous woman, not seen before. We gratefully sipped the clear, delicious brew, served in Kyoto porcelain cups. Our hosts handled the pots with reverence; these old pieces could have been made by their remote ancestors. Leaving our gift of cakes, we said goodbye and retraced our steps back through the village.

The kiln we had passed earlier was still smoking, and we climbed up the slope past little barns, mud fences and backyards to take a closer look. The hot smell of wood-firing, which I had come to know well from visits to innumerable other kilns in Japan, hung over the slope. Two firemen wearing broad straw hats, gloves and long cotton coats were attending to the firing, one working on each side of the long, low kiln. They worked slowly and deliberately, and communicated with each other, if at all, by invisible signs. The subdued roar of the fire was punctuated by the crackling sound made by each piece of wood as it was thrown into the blazing kiln through the little stokeholes. In the orange-red interior we could just make out the rows of pots bathed in flame (Pl. 127).

The afternoon was slipping by, and we reluctantly left the kiln to visit the local government ceramic research station and the museum. In the office of the government station (a group of nondescript wooden buildings huddled around a little courtyard), a potbellied stove was throwing out an incredible

blast of heat. Japanese interiors are always too hot or too cold. The office workers at the station gave us tea (more tea!) and directed us to the museum, which was up the slope a bit and standing in a little grove of trees. The museum is a charming building of half-timbered construction, modest in size and design. Inside, the chill of the morning was still held by the cement floor. In the crowded cases a large collection of Tamba pots is displayed, representing the productions of the village from earliest times to the present, all well labeled (in Japanese). The oldest pieces, great jars in a case near the entrance, are breathtaking. They stand in quiet dignity, dim in color, restrained in form, massive and sturdy. They exude a feeling of antiquity. They seem still to be a part of the earth, and their power goes beyond any nameable quality. The spirit of old Japan speaks directly through these simple jars, and all barriers of time, history, language, or culture sink away. Looking at these old pieces, I felt that Tamba wares were perhaps greater than Bizen, and more purely Japanese in feeling than even the pottery of the Mino district.

The valley was darkening now, and the pines were black against the remaining snow on the foothills. More people were on the street, going home from work or to the store. Women, talking quietly, bowed to us as we passed. We came upon a little black bullock, beautifully fat and groomed, tied up in a farmyard, and later we learned that this breed of bullock is, besides the pottery, the village's main claim to fame. I took a photograph of a row of saké bottles lying in the snow, their calligraphy making an intricate design with the crystalline snow. Our bus arrived almost on time, and we began the rough climb over the mountain and back to Arino.

Later in the year, we returned to Tachikui for a longer stay. This time it was rice planting season, and the valley, which had been frosty and barren before, was now a series of incredibly

beautiful flooded paddies. The smooth water of each precise field was broken by the delicate hairs of the rice shoots set out in rows. In fields not yet planted the little black bullocks were patiently pulling plows through the sticky mud. This time we followed the winding path out between the wet fields to the Tachikui shrine on the other side of the lush valley. Like many Japanese shrines, it is in a little cypress grove, somewhat sheltered from the surrounding fields. The ancient buildings were damp and mouldy, and the wet paving stones were covered with lichen. Two stone guardian "dogs" snarled at us from the entrance to the shrine. The place had the look of not having been visited by anyone for years. Swarms of gnats followed about our heads. The Tachikui shrine is a relatively poor one, no different from thousands of other half-neglected shrines throughout Japan. I do not know what god or group of gods it honors, but countless potters must have offered up their supplications here. Since shrines are visited mainly in times of stress, crisis or trouble, and at festivals, the gods of this shrine have no doubt been called upon many times to assist in the fire, to bring about the right kiln conditions, and to favor the wares with whatever qualities the potters thought to be desirable. This shrine site may antedate the establishment of the first kiln in Tamba, for the "Way of the Gods," which is the meaning of the word Shinto, is very ancient and grew out of the primitive animism practiced by the original migrants to Japan.

It has been an integral aspect of the culture ever since, and the later coming of Buddhism to Japan can best be thought of, in part, as a grafting of new elements onto the older beliefs and practices. The two faiths, Shinto and Buddhism, are not antithetical, and have in fact nourished each other. The importation of Buddhism from China brought to Shinto a richness of ritual, and to its shrines a richness of architectural

ornament, which had been lacking before. Buddhism, in turn, as it accommodated itself to a Shinto culture, gained an awareness of the immediate environment and of the various manifestations of nature. That most distinctive of Japanese art forms, the garden, although it developed as an adjunct to Buddhist architecture, owes much to Shinto; it is a hymn of praise to nature, and the earth itself is the medium. The spirit of the Japanese garden is deference to nature rather than dominance over it, just as Shinto religious observance is deference to the inner spirit of things, to the *kami* which pervade the rocks, the hills, or the sun itself. *Kami* are abstract essences, impersonal, and omnipresent. The idea of gods dwelling in stones, mountains or buildings is strange to the Western mind because we tend to separate the animate from the inanimate in our thinking. But if one could become aware of the continuity between the animate and the inanimate, a spirit congruent with a natural or a man-made object, the world might become quite different. A pot could be viewed differently; as a potential dwelling place of *kami* rather than as a mere husk of dead clay. Even a poor shrine such as that at Tachikui relates to the great shrine at Ise, in its giant cryptomeria forest, the most sacred spot in Japan. Standing before this weather-beaten gate one can sense intuitively forces of which we know little—forces that work their way throughout the continuity of nature.

In the warmer weather the potteries are more active, and the shops, which had been so damp and cold before, now seemed pleasant and inviting. Several kilns are usually functioning at one time, and one can have the excitement of seeing various kilns being set, fired, and emptied on the same day. We wandered in and out of many shops, including Tachikui's largest pottery, a semi-modern industry employing about twenty-five people and making, among other things, the little

disposable teapots sold on train platforms. In the shipping room of this shop an old woman sat inspecting and packing teapots (Pl. 84). She was sitting alone amidst thousands of teapots piled up nearly to the ceiling on all sides. But even this place had more the feeling of a craft shop than a factory, in spite of the use of molds and slip casting.

We sorted through hundreds of pieces piled up in the pottery yards, studied the kilns and firing, observed the throwing and jiggering of pots. All of this varied activity goes on at a steady and imperturbable pace. One senses the rhythm of the village as unhurried and proceeding with some independence from pressures of time. Pots are not made merely as a response to orders or needed income. They are as well the natural outcome of pleasurable work.

There is more to Tachikui than first greets the eye, and with further exploration we discovered houses not seen before, paths, little gardens, bamboo groves, an obscure road leading back to the mountains, and a second store removed from the main street. Although Tachikui has over one thousand inhabitants, it seems a much smaller place. Television reaches it across the mountains which surround the village. It is not a prosperous place, but it is not really poor either. There are few automobiles in evidence, but each pottery shop has a autobike and several bicycles parked nearby. Dark-uniformed students suddenly appear at five o'clock in the afternoon, having returned from the school in the next village.

Pottery in this place is an occupation considered no better or worse than farming or vending. It is a way of making a living. The trucks bringing in the lumpy clay, the piles of pots ready for shipment, the great mounds of broken pieces, the thickening mud in the settling ponds, the black smoke rising from the kilns—all of these are features of the landscape and a part of the look of the village. The oldest inhabitant no doubt looks upon

such scenes as being not much different now than they were decades ago. There is a local pride in the pottery. The people of Tachikui know that the name of Tamba stands for something in Japan, something of importance in the nation's heritage. Although the wares of Tamba have become famous, it is known that they were created in this little village by clay-coated, part-time farmers. In the past, as in the present, they coaxed the soft clay up into pottery shapes with their rough and sturdy hands, kicked the wheels with straw-sandaled feet, split the firewood, and breathed the hot, acrid fumes from the burning kilns. Then as now, pottery was an inseparable part of everyday life.

Although change has been slow in Tachikui, the twentieth century has brought varying fortunes to the potters. In the early part of the century, production dwindled, and after 1915 only four kilns were operating. (There are now about twenty active kilns.) All four of these kilns were communal, and they were kept going by small, family-sized shops. Up until 1930 there were few dealers operating, and the distribution of the pots was done almost entirely by peddling. In the early thirties two regular dealers were in the business of selling the wares of Tachikui.

The pottery forms made at Tachikui were influenced in various ways by the times. About 1905, the production of large saké bottles was greatly increased; there seems to have been a dramatic increase in saké drinking in Japan at this time. Tamba saké bottles were even exported to Korea for the use of Japanese occupation forces in that country. Towards the mid-twenties a barrel-shaped saké bottle was made in quantity.

When the present emperor was coronated, the potters made a planter in his honor with a chrysanthemum motif in sprigged clay, and this became a very popular item. About 1932, the jigger wheel and mold were introduced at Tachikui. This was something of a revolution for the pottery shops and

permitted them to compete in the market on a more equal basis. It is quite remarkable that the potteries at Tachikui, which in most ways are relatively primitive and which retain the Korean-style kiln of the Edo period, should adopt forming methods which are mechanically more advanced than those of many other rural Japanese shops. Of course, the old hand methods persisted right along with the more mechanized techniques, and the continuity of tradition was not really broken. The introduction of power wheels and molds was stimulated by government research and aid. Such assistance, at Tachikui and elsewhere, seems to have been generous and intelligently directed.

During the China Incident in the thirties, outside regulation and control was felt at Tachikui. The government set up a cooperative to allocate and regulate the use of raw materials and power. The production of acid bottles was begun at this time. Also during this period, the production of water jars was greatly stimulated by metal shortages, which gave an advantage to pottery as a material for providing storage vessels.

The potteries were somehow able to keep going during World War II. They made medicine bottles for the military, and towards the close of the war produced ceramic covers for land mines. As it turned out, these mine covers were never used, and it is good to know that no soldier was ever wounded by a pottery fragment from Tamba. After the war was over, the acute metal shortage continued to create a demand for all types of pottery, and production at Tachikui reached the highest level of modern times. But this demand has since tended to diminish, and recently the future of the kilns has seemed in some doubt. Plastics, which are extremely popular in Japan, have tended to replace pottery for many utilitarian functions. Indeed, the ceramic teapots formerly sold at railway stations have been superseded almost entirely by plastic ones. It would

be logical for the potters to shift from making water jars and saké bottles to the production of souvenir and export pottery, but Tachikui is not in a particularly favorable competive position for the "folkcraft" trade. Its pottery has been traditionally plain, low-keyed in color, and not immediately attractive to foreign buyers.

Although Tachikui has been traditionally limited to a few pottery forms, in modern times the market has become less stable, and some of the potters have shifted from one production item to another in response to demand. They have been pushed by necessity to make whatever would sell. At Tachikui today, one can see acid jars and planters, which are shipped directly to Osaka and Kyoto for sale, specialty items such as little jars for temple souvenirs, plates of various sizes, disposable bowls used by train vendors, and various tea wares. These tea wares, including teabowls, waterpots and the like, are made in several small shops and in a variety of styles, not necessarily in styles recognizable as Tamba.

Among these various present-day wares, there is little of outstanding quality, and one must conclude that as far as superior pottery is concerned, Tachikui is in a period of decline. This is unfortunately true not only of Tachikui, but also of most of the country kilns in Japan. The forces of commercialism, industrialization and centralization are bringing about inexorable change. Young people are no longer content to train as potters, knowing that, whatever the satisfactions of the craftsman may be, he is likely to face a lifetime of hard and economically unrewarding labor. Thus, the transmission of skills and tradition is more uncertain now than it has been during any time in the long history of the kilns. Well-wishers among the lovers of folkcraft have tried to keep something of the old values alive, and have patronized certain Tachikui potters in an effort to help them preserve something of the

former quality and integrity of work. But this effort is vastly outweighed by economic and social forces, particularly dynamic and compelling in Japan with its rapid economic growth.

The wonder is that anything at all is left of the old spirit of Tamba pottery. And something *is* left. Many fine and sturdy pots are still made, and the robust slip glazes still fire at times with a wonderful richness and earthy vitality. Pride in product is by no means gone, nor is a sense of continuity and respect for the past on the part of the potters. But some of the very strengths of former times work against Tamba now. The division of labor between farming and potting, which always before contributed to the stability of the community and to the character of the wares, now makes competition with more specialized industries difficult.

The pottery shops at Tachikui are in buildings that are actually adaptations of the local form of barns or storage buildings. Sometimes they are connected to the house, but more often they stand by themselves. They are of the usual Japanese timber and wattle construction, and the considerable span inside necessitates quite heavy roof timbers. The larger shops have lofts or attics used for storage. The shops tend to be dark, with windows occupying no more than about four percent of the total wall area. This lack of windows probably is a result of the expense of glass. Also a small window area lessens the danger of frost damage to the pottery during the winter, for the shops, like most buildings in Japan, are inadequately heated. Smoke from the fire escapes, more or less, from a hole in the roof, and the ceilings become darkened with soot. In the winter the hibachi is also used for warmth, but these small charcoal braziers give only local heat and do not relieve the chill of the whole interior. The shops have racks built overhead for storage of pots and molds. The floor is of clay, smoothly packed.

Most of the larger shops have electric power, and a large electric motor and belt system delivers the power to the machines. In some shops the same motor operates a rice mill. The motor runs the pug mill for mixing and extruding clay, and also the jigger wheel. Most of the shops have various sheds tacked onto them in which are stored clay, molds, finished pots and wood. As in practically every Japanese interior of any sort, space is scarce, and there is a feeling of overcrowding.

Since the local sources of clay have long since been exhausted, the clay is now brought from Arima, some miles away. Two kinds of clay are blended: the yellow hill clay, and a black surface clay, which is added to increase plasticity. Formerly more attention was given to selecting the clay, but today better processing makes this less necessary. The potters buy up clay land by the *tsubo*, (an area about six feet by six feet; the standard land area unit in Japan). Three feet of humus and soil is removed to uncover the clay, which is four or five feet thick. Each *tsubo* of clay land yields several truckloads of clay. The clay is dumped into a mixing tank, usually of concrete, where water is added to form a thin clay slip. When this slip is uniform and smooth, it is ladled through a screen into an adjacent tank, and there it is allowed to settle (Pl. 90). The water which rises to the top is returned to the first tank by opening a bung between the two tanks. The thickened clay, now the consistency of pancake batter, is scooped out of the tank and spread on bamboo mats propped up on frames (Pl. 93). Here, the water drips down from the clay through the mats, and the stiffening process is continued. Final stiffening is accomplished by placing the clay in pottery or plaster drying bats (Pl. 92). The clay-making process is laborious and slow, and much impeded by damp weather. The potters try to keep ahead on clay production, and most shops seem to have a considerable supply of plastic clay in the shop, enough for perhaps two

weeks' production. Most of the shops make their own clay and do not buy it from any person specializing in this particular part of the work. Pug mills were introduced to prepare the clay for the jigger wheel, but for throwing, the clay is still kneaded by hand. The spiral wedging method is used, and the clay, under the rhythmic thrust of the potter's hands assumes a beautiful shape; sometimes likened to a sea shell the process is called *kiku-momi* ("chrysanthemum kneading") in Tachikui (Pls. 94–98).

The jigger wheel at Tachikui is not essentially different from that used in Western pottery factories, and the molds that fit into it are made of plaster. We did not see molds being made at Tachikui, but they are produced locally. Acid jars, some plates, and planters are made on the jigger wheel. The acid bottle is made in two parts and luted together when leather hard. The planters are finished by hand on the potter's wheel after jiggering; the lip is smoothed and the foot trimmed somewhat.

The potter's wheel at Tachikui is Korean style, operated counterclockwise. The shaft of the wheel is oak and the other parts are made of chestnut wood. The wheel head is of wood. The wheel is short, and the flywheel small and light, with very limited momentum. Formerly these wheels were set in an earthen pit, as in Korea, but now they are built into a wooden bench. The wheel is operated by foot, mostly by the pawing action of the left foot. The Tamba potters have never used the wheel running clockwise and activated by hand with a stick fitting into one of four notches in the heavy head, as is common in much of Japan. The throwers use the coil-and-throw method for all larger shapes; that is, they start with a clay disc or slab for the base and build on this with thick coils, smoothing and extending with the wheel running more rapidly. As in Korea, the potters use the rib for shaping and smoothing, and the

flannel cloth for raising the form and smoothing the edge. This flannel cloth is stitched with linen thread to thicken it and is used much like a sponge. A wire or thread is not used for cutting the pots off the wheel; they are removed with a large spatula. Or, more often, the pots are made on wooden bats, which are lifted off the wheel and recentered later if further work on the pot is needed. As in many Japanese pottery shops, the water for wheel work is warmed over a small hibachi in the winter. For comfort when kicking the wheel the potters at Tachikui wear straw sandals, and sometimes keep an extra pair handy. In former times the potters wore only the ubiquitous rice-straw sandals whether at the wheel or not.

Pottery making methods are more or less alike the world over, and if one went to Tachikui expecting to find unique methods which are rare or unknown elsewhere, one would be disappointed. But Tachikui is notable for some techniques which, rather surprisingly, are not used. As mentioned earlier, trimming is not much used. Also, until recently, pots were never thrown from a hump of clay and cut off one at a time, as is common in other Japanese potteries. But by and large, the methods used at Tachikui are those one would expect in any shop where quantities of pots are being turned out with the least expenditure of time and labor. Generally speaking, all the pots made are production items, and there are few individually treated pieces, or pieces for which the potter has any special hopes other than the normal shape and finish for that particular form.

Since modern Tachikui pottery usually is fired only once, applications of slip and glazes are done on the raw ware. The selection of glazes is still severely limited, although more varied than in former days. The old recipes for red-brown and black are not used now. The black glaze presently used contains a dark iron-bearing stone, manganese, cypress ash and a fine red

clay. A clear glaze is made by combining straw ash and stone from the Kyoto area, "Kamogawa stone." The so-called *ame* glaze, popular all over Japan, is made at Tachikui, as elsewhere, from mixtures of straw ash, clay, and sometimes manganese. It runs in streaks and derives its name from a similarity in color to the traditional amber-colored candies (*ame*) still sold throughout Japan. Perhaps the most common glaze at Tachikui, one which is always used on the acid jars, is known as *kimachi*. It is a natural slip glaze imported from the neighborhood of Kimachi, and it burns to a pleasant red-brown, sometimes streaked with black, and somewhat resembles a *temmoku*.

Glaze materials are stirred in a tub, screened, and wet-blended for different recipes, using the dipper for measure. Pots are glazed by dipping, pouring or immersion in glaze. Saké bottles are glazed inside by using a funnel to guide the glaze into the narrow neck. A tin can is now sometimes used to scrape the glaze off the bottom of pots. Saké bottle characters are trailed in white slip. This takes considerable skill, and there are few potters in the village now who specialize in using the slip trailer (Pl. 122). Workers who are skillful with the slip trailer are usually employed at shops making *mingei* ("folk-craft") style pots. Not many glazed raw pots are to be seen in the shops because they are loaded into the kiln as soon as they are completed, thus relieving the space problems in the shop.

The kilns now in use at Tachikui are indeed interesting survivals of the past and are quite different from any others in Japan. There are over twenty kilns operating, all quite similar in design and construction. The kilns are about 125 to 140 feet long and are built on an upward slope of about thirty degrees. This happens to be the natural average slope of the hill behind the village and is approximately the same as the slope of the older cave kilns. The kiln is essentially a long tube, partially buried in the earth. The kiln is made of cubical, handmade

refractory bricks, measuring about six or seven inches to a side, and laid up with considerable clay mortar. The crown is a self-supporting arch. The interior of the kiln is over five feet across, and about forty inches high. Along the kiln, seven or eight doors are spaced, and near the doors the kiln bulges out a bit to form a wider interior space. Just before each door there is an articulation of the kiln, formed of several upright supporting columns of brick stretching from floor to arch. On both sides of the kiln there are about ten small stokeholes between doors. At the lower end of the kiln there is an igloo-shaped main fire mouth (Fig. 2, p. 132).

The Tamba kiln has a very organic form and looks more like some natural object than a man-made oven. The outside of the kiln is plastered over with clay, which becomes cracked and darkened with soot. Flat rocks are laid against the kiln at grade level to help buttress the arch. The doors are quite irregular and have a sculptured quality. The inside surfaces of the kiln are sintered over into a rich glazelike surface, varied in color and texture. The kiln has more than one thousand cubic feet of ware space.

Loading the kiln is a laborious operation because of the lack of headroom. The pots are carried into the kiln in baskets and set in layers on the floor of the kiln. The bottom pot of each stack is placed on a pad of clay, and these pads are used again and again. No shelves or props are used and the pots are put one on top of another, or nested together. Acid jars, whose shapes are not adapted to stacking, are set in one layer only. Rice-hull ash (ninety percent silica) is brushed on between the pots where there is a danger of sticking. The potters crawl into the kiln to place the pots, crawling back for another load until each section is filled. Some empty space is allowed in the area near the stokeholes where the wood will be thrown in. Saggers are used for some pots, such as tea sets and the like, where uni-

formity of glaze is desired, and unglazed planters are often used as saggers, with small glazed pieces placed inside (Pl. 129). Pots are set on little wads of clay, and saggers are separated by rolls of clay. No pyrometric cones are used: the potters rely entirely on the color of the interior to judge the progress of firing.

In principle, the Tamba kiln is a simple device. The long chamber, built on an upward slope, provides a strong draft, and no chimney is necessary. Air is drawn in at the mouth of the tube, furnishing oxygen for the combustion of the fuel. This strong draft permits rapid burning and the release of large amounts of heat, and thus very high temperatures are possible.

At the start of the firing, a candle is lit in a little shrine on a roof beam at the mouth of the kiln. The long firing process is thus begun with a small votive flame. A fire is lit in the main fire mouth, small at first, and gradually built up in intensity. At this early stage of firing, rather large pieces of wood are used, since rapid burning is not desired. The firing is continued in the fire mouth for a long time—a total of about forty hours. The first part of this long period actually serves to dry out the kiln and to warm up the whole interior to induce proper draft. After twenty hours, the temperature in the second chamber only reaches about $300°$ C. But then the fire is stepped up, and after forty to forty-five hours the temperature in the second chamber is about $800°$ C., an orange-red. At this point, the firing is discontinued at the mouth and proceeds through the side stokeholes of the first chamber. The temperature then rises very rapidly—small pieces of wood are first thrown in on top of the pots in the upper part of the chamber; a little later, the wood is poked down into the lower part, and the draft, now every strong, enables an extremely rapid release of heat. A man works on each side of the kiln, stoking, and poking into the kiln with an iron poker (Pl. 125).

Two hundred bundles of wood are consumed on the warm-up and the firing of the kiln through the main fire mouth. (One bundle of wood weighs approximately eight pounds.) About twenty to twenty-five bundles of wood are required for each of the eight chambers. The wood is stored along the top of the kiln before firing, and the heat of the kiln insures that the wood, when used, will be bone dry.

When the temperature of one zone of the kiln rises to about 1250° C., the firemen move up to the next pair of stoke-holes. The firing proceeds in this manner up the entire kiln, and about thirteen or fourteen hours is required to finish after the start of the side-firing. More time is actually spent firing the main fire mouth than is spent in bringing all chambers up to heat.

Once the firing gets well under way, it is very rapid, and the advance of heat is very sudden. Also sudden is the cooling. The air for combustion is, of course, entering the fire mouth, and the inrush of this air tends to rapidly cool those parts of the chamber in which the firing has been completed. In two hours, the lower part of a chamber will drop from 1250° C. back to 900° C. The soaking time at highest temperature is very short, usually less than one hour. This short cycle of heating and cooling is not the best condition for the development of various high-fired glazes, and in this sense the design and operation of the kiln is a somewhat limiting factor.

The firing at Tachikui is rather neutral in atmosphere, neither oxidizing nor heavily reducing. The setting of the ware and the manner of stoking does bring flame into contact with most of the kiln setting, and there are no baffle walls or saggers to divert the flame. For this reason, flashing is widespread throughout the setting. Because of the short duration of the fire, however, a very small amount of ash is deposited on the pots.

When the firing of the last chamber is completed, the honeycomb flue on the end of the kiln is sealed with clay. By this time the first chamber, through which the air for combustion for all subsequent chambers has been passing, is quite cool, almost cool enough to unload. About twelve hours after the sealing of the kiln, the first chamber is unstacked. It is quite cool by this time, but again, the potters must crawl into the kiln to bring out the finished ware. Losses are great, partly due to uneven firing, and also because of breakage where the wood has struck pots as it was thrown into the kiln through the stokeholes. A considerable amount of sorting and discarding goes on right at the kiln door and great piles of broken pieces build up. Women do much of the work of unloading and carrying the wares back to the shops (Pl. 128).

Most of the Tachikui kilns are fired about once a month. Formerly, when longer kilns were used, they were fired much less frequently, perhaps only three or four times a year. The present schedule is more economical and gives the shops more flexibility in filling orders. During the years right after World War II, water jars made up a large percentage of the output— as much as thirty percent. This has now dropped off to a small production. With the present growing interest in folkcraft pottery, the small, individual potters are producing larger quantities of household and table wares and decorative items such as vases, while the factories now concentrate on small porcelain saké barrels.

When asked, most of the potters at Tachikui give their occupation as "farmer," and most of them do farm on a part-time basis. But they also have the responsibility of a business, with all that entails in ordering materials, keeping the shops operating, and marketing. Somehow they manage to carry the pottery work along, together with seasonal work in the fields, tending livestock and all the other chores of the farm. All of

this would not be possible but for the work of every member of the family, both young and old.

Marketing pottery is difficult because Tachikui is so far from the consumer. Now, most of the pots are bought by jobbers, who order certain things from the various kilns and who pick up the ware at the kiln. A few dealers used to live at Tachikui who devoted all their time to buying and selling, but now outside agents and jobbers are relied upon.

Not long ago, peddling was an important method of selling pots. Very few casual visitors or buyers came to Tachikui, so the pots had to be taken elsewhere for sale. Women often did the job of peddling—widows and farmwives who needed money. They carried a great load of pots on their backs, traveling by bus to some nearby town. There they would visit various farms and homes, selling from door to door. Often they had to visit as many as one hundred homes to dispose of the day's load of pots, and they always aimed to sell all of the pots before returning to Tachikui, even if this meant drastically reducing the price and selling for a loss. The profits from such pedding were pitifully small—perhaps a dollar a day or less.

Peddling was also done by men. Three or four men, potters or workers in the potteries, would rent a truck, load it up with pots and drive to some distant place. One of the men would return with the truck and the others would stay with the pots at some cheap inn. Then, for about fifteen days, they would sell from farm to farm and door to door, until all the pots were disposed of, returning home by bus or train. This system of peddling was mostly used by the smaller shops. It was a poor man's distribution system. Of course the rental for the truck, the train and bus fares, and living expenses while away cut drastically into the profit.

The peaceful aspect of the valley, the quiet homes and fields, and the steady and rhythmic pace of village life conceals, in a

way, a harsher reality which typifies the life of the potters at Tachikui. Work, for them, although it has the satisfaction of resulting in a useful object made with skill and knowledge, is an unremitting necessity, and leisure is more a time for recuperation than for pleasure seeking. It would be a mistake, certainly, to romanticize the life of the potters there, or to imagine that the craft brings any special values not shared by the rural Japanese population in general. For craftmanship is built into Japanese life, and I doubt if pottery making has any special quality much different, as far as the worker goes, from tilling a rice field, making tatami mats or pickling vegetables.

Consider the life of Mr. Tanaka (not his real name), a farmer-potter of Tachikui village. His general situation is quite typical, and perhaps three-fourths of the potters are in about the same situation as he is. Mr. Tanaka thinks of himself as a farmer, and for him pottery is something of a moonlighting job. The fact that he owns some agricultural land is a source of pride. He holds about one and one-half acres of good, irrigated valley land, and one-half acre of woodland. He rents out a vegetable plot to a neighbor, about one-eighth acre (the size of a city lot). Mr. Tanaka has a wife and four children under ten years. His parents live with the family—making eight in the family in all. Their modest house in the village has a space for the cow (rather an unusual asset), a tool shed, and a pottery room attached to the house. The pottery shop is equipped with two electric jigger wheels, a pug mill and two foot wheels. Mr. Tanaka rents the motors for the wheels and the pug mill. He does not own a kiln, but rents space in a kiln only a few steps away from the shop. He makes mostly planters, which are turned out on the jigger. The kiln is fired about once a month, and Mr. Tanaka takes a turn at the firing. When it is his turn to attend to the early part of the firing, this means long hours of work. But the firemen spell each other in shifts.

In the old days many superstitions prevailed as to the success or failure of kiln firing. Only vegetarians were kiln firemen, because of the Buddhist taboo against meat eating. Also, women, considered to be carriers of bad luck, were not allowed to go near the kiln while it was firing. Even today, women have nothing to do with the firing.

In the summertime, Mr. Tanaka gets up at 4:30 or 5:00 A.M. and walks down across the river to his fields. Here he attends to irrigation or other matters. He comes back home and works on clay processing, bailing the slip from the mixing tank through the screen into the settling tank. Some work on clay must be done each day to keep up the supply. After two hours work on clay, Tanaka has a breakfast of rice, raw egg, a hot bean soup, and tea.

At 8:00 A.M. Tanaka goes to work in the shop, doing the varied work of jiggering, trimming, handling the molds, glazing, or kiln setting—whatever is needed to advance production. At noon he has lunch and a one-hour nap, going back to work at 1:30. He works until 7:00 P.M. with one break for tea. Again he walks out to the field, where he helps his wife, who has been in the fields all afternoon. They come home at dusk, have supper, and retire at about 10:00 P.M.

Tanaka's wife spends the day either in the fields or helping in the pottery, and besides she tends to the needs of the children, does the family laundry in the river, and cooks the meals. The grandparents do what they can about the house and help care for the children.

Life for Mr. Tanaka is more strenuous in the summer, because the fields and the pottery both are more demanding of time and effort. Pottery making is easier in the summer than in the winter, and sales are better. But winter has its trials too, including the difficulty of preparing clay, and the complication of every task by cold, frost and mud. In the summer, Tanaka

hires some help in the pottery, but these are only occasional workers, and he does not feel responsible for them.

Tanaka considers himself quite well off. He is independent and not in debt. He feels no obligation either to employers or employees, which in Japan may mean a much-to-be-desired freedom from anxiety. The management of his business is fairly simple, and while he puts in a tremendously long day, the atmosphere of the shop is pleasant and serene. The fact that he cannot save for the future is not a matter of great concern, since normally the Japanese farmer or worker does not have sufficient earning capacity to save much out of income, and he assumes that he will be cared for in his old age by his children just as he has cared for his parents.

In contrast to Mr. Tanaka, Mr. Shimizu, as we shall call him, is primarily a potter, although he owns one field in the valley, which he rents out. He is an important man in the village, was once a councilman, and was active in the potters' co-operative. He now devotes full time to his pottery shop and is helped by his wife. They have no children. His shop is well equipped with a pug mill, two electric wheels and kick wheels. He owns a nine-chamber kiln, and also a bisque kiln.

Mr. Shimizu runs a family business. He is the owner, but he depends largely on his relatives for labor. His older brother, his nephew, and the son of another more distant relative work regularly in his shop. In a way, these men are more like partners than hired hands, but they do not depend entirely on wages from the pottery. Mr. Shimizu works full time himself at various chores. He hires extra help from time to time for firing and odd jobs in the shop.

Mr. Shimizu has the advantage of being well connected and on good terms with the city buyers. His production is varied, and includes acid jars, planters, and saké bottles. He has experimented with making tea wares. Previously he acted as a dealer,

and thus made connections which help him in selling pots. At times he has more orders than he can fill, and he passes on business to some of the smaller shops run by friends of his. On these orders he only takes a small commission. Shimizu is a successful potter who has achieved independence and some security, values which he protects by hard, unremitting labor and attention to all the details of his shop.

Mr. Tanaka and Mr. Shimizu are independent entrepreneurs, and although they work tremendously hard, they have the satisfaction of being in control of their own fortunes to some extent. The majority of the labor in the potteries, however, is performed by hired hands who do not own any of the equipment or facilities. These are the poor relations of the owners, the women who need work to supplement the family income, youths who are getting started in life through apprenticeship, and the ordinary hired hands who by circumstance or endowment have been kept in the laboring class. The wages of these workers is usually less than the amount required to support a small family, even at a living standard considered minimum in Japan.

Societal factors in Japan in the past, and to a much lesser extent and in a different sense today, have favored the development of a great variety of handicraft skills, and have made possible the preservation of traditions of design over long periods of time. Pottery, especially, is a craft which seems to have been suited to the way of life of rural Japan.

In Japan, as in other traditional societies, there has been a lack of emphasis on individualism. The individual finds his expression in terms of the group, and great value is placed on the harmonious functioning of the individual in the social context in which he finds himself. Thus, it is possible for the craftsman to submerge himself in an enterprise which involves the repetition of traditional forms, forms for which he takes no credit

for having originated and for which he feels, rather, a pride in having successfully repeated and perpetuated. The problems of his ego and its expression in outward form do not come up. In the crafts, this submergence of individual caprice permitted the ripening of styles over long periods of time during which the unconscious and subtle contributions of countless workers, each perhaps small in itself, were summed up in the matured expression.

The relative de-emphasis on the individual improved the chances of success for all cooperative ventures. Pottery making depends upon cooperative effort, and to be successful the pottery shop must be a place where the work of many persons is reasonably well organized. There must be collaboration in the preparation of the raw materials, the throwing and shaping of the ware, the decorating and firing, and even in selling and distribution. The mutually supportive efforts of the workers in the pottery shop were not essentially different from the intricate systems of cooperation which characterize Japanese rural life in general. In rice planting, building, roof repair, bridge and road work, and in aid to the bereaved, the Japanese farmer is accustomed to close and productive working associations with his fellow villagers. Well-defined roles and traditional methods of accomplishing particular tasks make such mutual aid effective and relatively free from tension. Moreover, the group activities of the village have benefited from a broad base of participation, with men and women, young and old working together. In the potteries, although certain tasks seem never to have been assigned to women, men and women worked together, and older persons were accorded an important voice in the direction of the work, a voice in keeping with their experience and judgment.

The commitment of the average Japanese worker to his job is a difficult thing for the Westerner to understand. In Japan it is

uncommon for a man to change occupations or to move from one place of employment to another, and a young man may expect to spend his entire working life in the same job which he takes when he leaves school. Thus, the craft shops have been operated by people who, for better or worse, were totally committed to the work, and who, because of their long tenure in the job were apt to become highly skilled in what they were doing. This commitment seems to foster a positive identification with the work, and a will to make the best of the situation. Although the potters may have been in reality driven by stern economic necessity to work for long hours in what we would regard as very difficult circumstances, they accepted such circumstances and responded to them with the same attitude toward a harmonious relationship between environment and self which characterized Japanese social behavior—there was hardly a question of resentment; work was done but with cheerfulness and patience. Given this harmonious relationship with one's conditions, and thus with a love for the product itself, work can become its own reward rather than something onerous and endured during an inescapable, set period of time each day. The Japanese also consider loyalty high among the virtues, and loyalty can furnish a strong cement even to an enterprise involving great hardships and difficulties. In the Japanese workshop, obligations as well as expectations are accepted and acted upon by all persons involved.

The Japanese custom of passing on to the eldest son the profession or occupation of the father has been a significant factor in the preservation of traditional ways of doing things over many generations. Because there was no generational break, continuity has been possible in the pottery shops, with little change occurring when any particular potter passed from the scene. Even when a man has no son, he may adopt one to carry on his work, or he may adopt the husband of one of his

daughters, making him an heir and successor. Since the son enters a trade or shop which he has known since childhood and which represents to him the accumulated effort of his forebears, his natural tendency is to carry it along as it always has been. New ways of doing things are not sought after, and new ideas are not valued as much as the faithful following of the old. Changes occur imperceptably, coming about in response to subtle and pervasive influences rather than as a result of individual caprice or inspiration.

Thus, the Tamba pots became vessels reflecting with some precision various aspects of the culture in which they were made. We can easily read the obvious signs which tell of the techniques and the materials used. Beyond this, if we are attentive and open ourselves to the subtle forms and textures of the pots, we can get some sense of the lives of the potters.

*Editor's Note: Recently the Tachikui potters have formed a cooperative to process clay. The clay settling ponds are no longer in evidence in the village. Changes of this type now occur with increasing frequency in Japan. Similarly, Mr. Ichino has built a spacious, concrete-block workshop since this text was written.

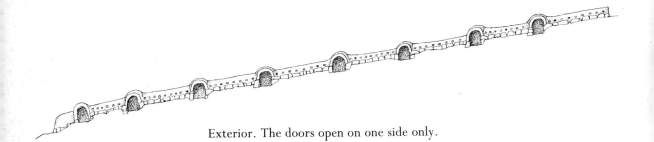

Exterior. The doors open on one side only.

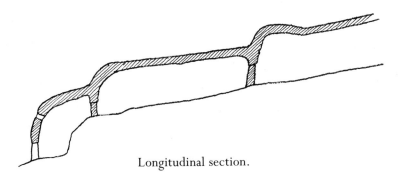

Longitudinal section.

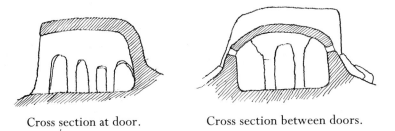

Cross section at door. Cross section between doors.

Fig. 2. An eight-section kiln at Tachikui.

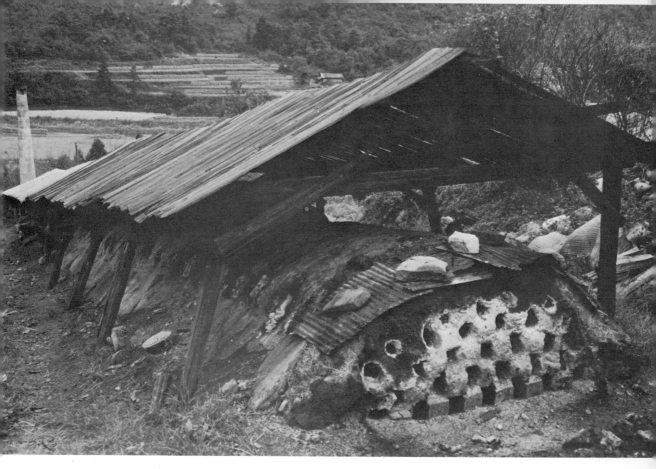

73. Upper end of a Tachikui kiln with checkerwork or "honeycomb" flue.

74. Tachikui kiln. Here the original cypress board roof has been partially replaced with galvanized iron.

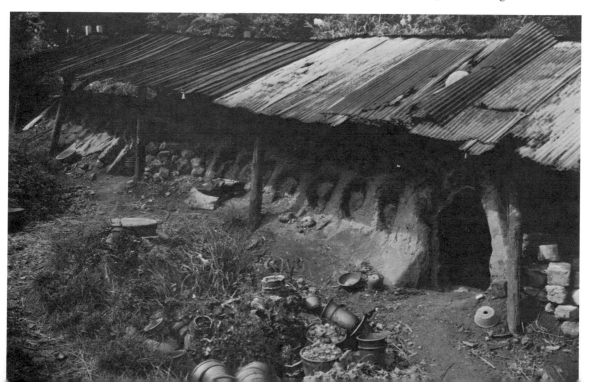

75. View of Tachikui village from the shrine at the north end of the valley. It is late summer and some of the rice has been cut and hung to dry.

76. Central shrine in Tachikui. The large Zelkova tree behind the shrine is said to be seven hundred years old.

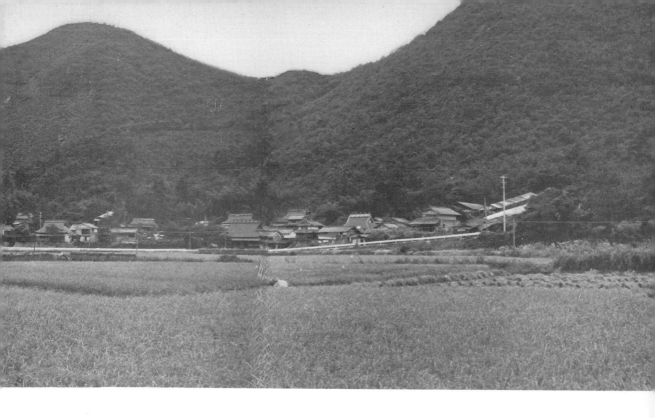

77. Ruin of an *anagama* or cave kiln near Tachikui. The roof is partially caved in. That such kilns still survive after several hundred years is evidence of the toughness of their fire-hardened walls. Many pottery shards can be found near the mouth of these kilns.

135

78. Tachikui. The rice fields at the left are divided from the houses and shops by a small stream.

79. Two kiln sheds made of cypress boards. These wooden kiln sheds have almost all been replaced by corrugated iron. It is spring, with light green, feathery new bamboo in the middle distance and branches of young leaves hanging over the kiln.

80. Smoke rising from the kiln. Rice terraces are in the distance.

136

81. A Tachikui pottery workshop in winter. Freshly made pieces are drying in the yard.

82. Straw-thatched potters' houses at Tachikui. These thatched roofs are rapidly being replaced, or covered with flat galvanized iron.

83. Center of Tachikui. The little Shinto shrine, with its modest *torii* made of peeled logs, is at the left.

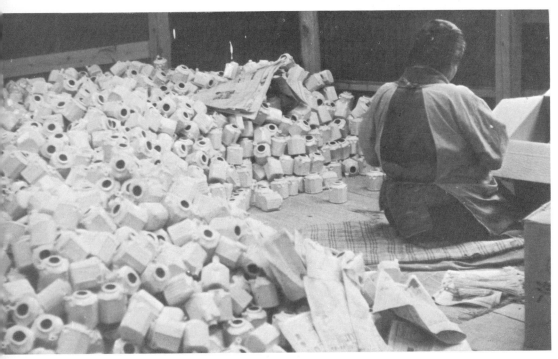

84. Sorting and packing teapots. These little disposable pots are given away with the purchase of hot tea at train stations.

85. Finished acid bottles. These rugged shapes have something of the character of Tamba wares, even though intended for industrial usage.

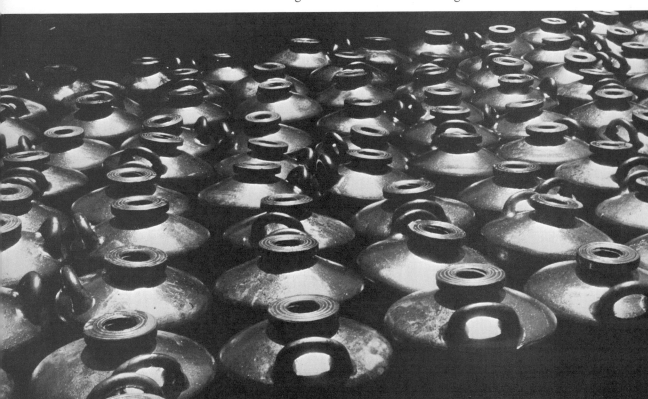

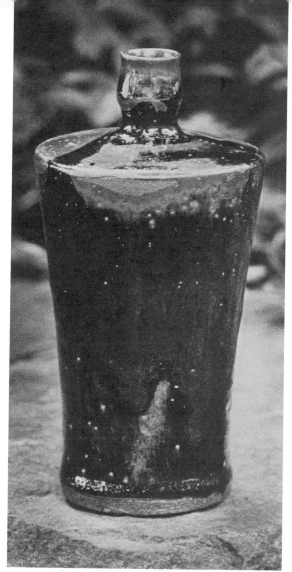

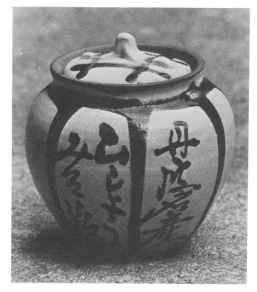

87. Covered jar. Contemporary. Thousands of jars of this type are made at Tachikui as containers for pickled *sansho* seeds. The glaze is white with the inscription trailed in brown. *Height:* 4.25 in.; *Collection:* the author

86. Saké bottle. Contemporary. This piece, in the familiar Tamba "candle" shape, has a rich brown to black slip glaze. *Height:* 6.5 in.; *Collection:* the author

88. Bottle. Contemporary. This tiny piece has a handsome slip glaze, with the characters trailed in white. *Height:* 4.0 in.; *Collection:* the author

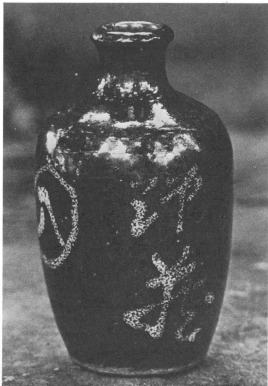

89. A large, modern platter by Hiroyuki Ichino. The design in a dark green glaze has been trailed with a bamboo tube over a black ground. This is an excellent example of traditional techniques finding application in a "modern" design. *Diameter*: 24.4 in.

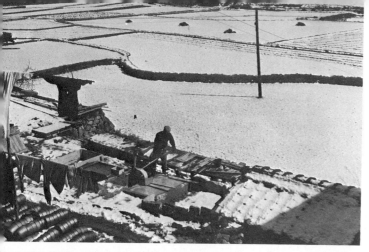

90. Against a background of snow-covered rice fields the potter screens clay into a settling tank.

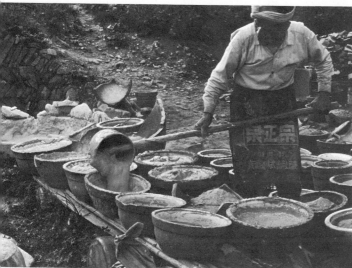

91. The potter ladles the heavy clay slip from the settling tank into porous pottery bowls, where it will stiffen to plastic consistency.

92. Clay stiffening in the drying bowls.

93. A clay settling pond and an improvised drying surface made by stretching burlap over bamboo poles.

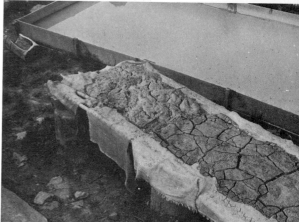

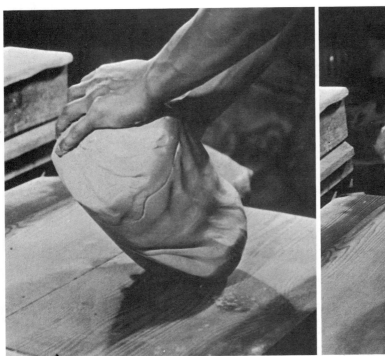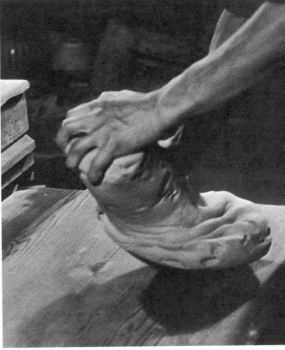

94. Starting to wedge a lump of clay using the spiral, or *kiku-momi* ("chrysanthemum wedging"), method.

95. The lump is given a spiral twist.

96–97. Continued wedging forces the clay into a spiral path and gives the lump a shape reminiscent of a seashell.

98. The final shape of the fully wedged clay is at the left; at the right the ball of clay is seen in the shape it assumes during the wedging process.

142

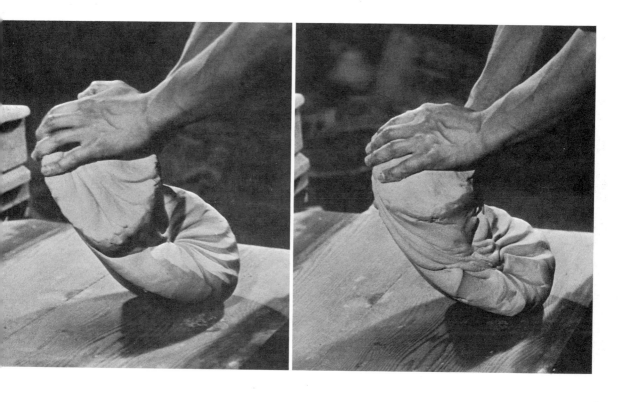

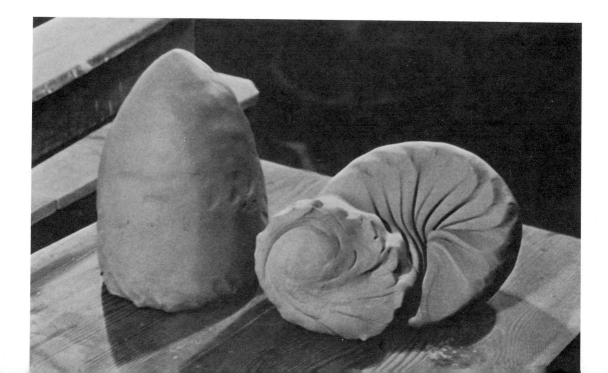

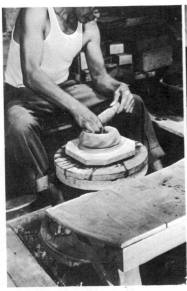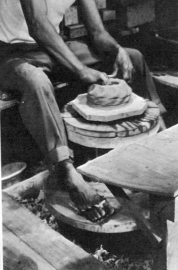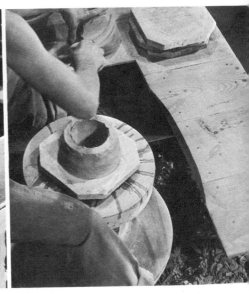

99. Making a pot by the coil and throw method. The wooden bat is fastened to the wheel head with soft clay. A disc of clay which will become the bottom of the piece is then made on the bat. Next a fat coil of clay is added to the bottom.

100. Pressing the coil into a compact doughnut shape.

101. The potter reaches for clay to make a second coil.

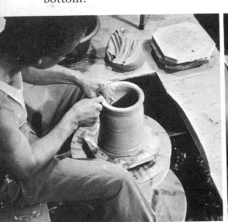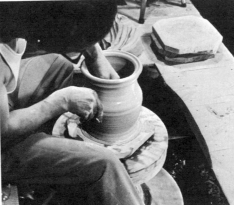

105. The rim is smoothed and given shape.

106. The pot is distended by pressure from the inside.

107. Widening the form.

144

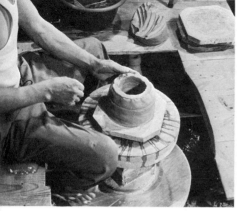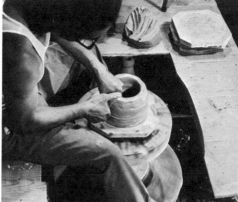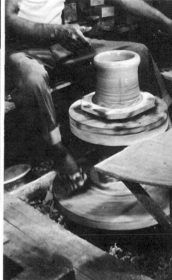

102. The second coil is in place.

103. The wheel is now turned rapidly, water is added to the clay, and the potter proceeds to shape the piece by throwing.

104. Irregularities are quickly smoothed out and the piece begins to grow into a taller cylinder.

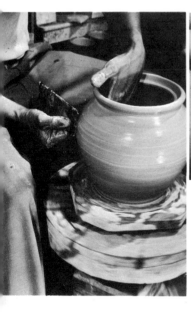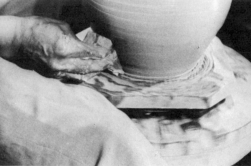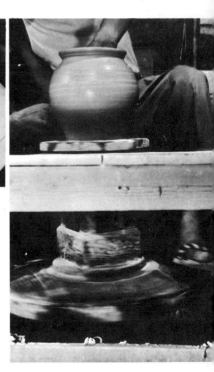

108. Finishing the pot with a wooden rib.

109. Finishing the bottom with a triangular wooden rib.

110. Finished pot on the wheel. The shaft of the wheel is very short.

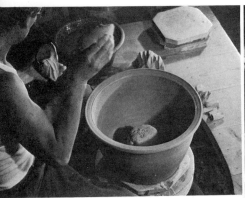

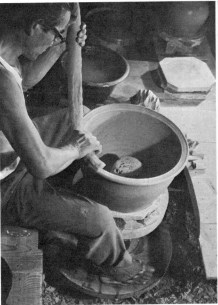

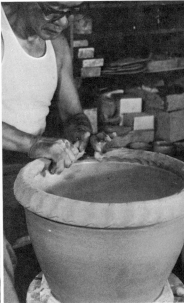

111. Finishing a bowl by the coil and throw technique. A rock has been placed inside the bowl to help hold it on the wheel. The potter wedges by hand a ball of clay from which he will make the coil.

112. The rim of the leather-hard bowl is moistened and the heavy coil is added while the wheel slowly turns.

113. The coil is squeezed onto the rim of the bowl.

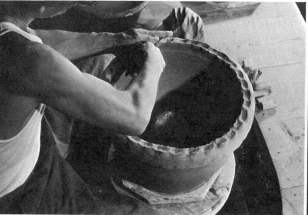

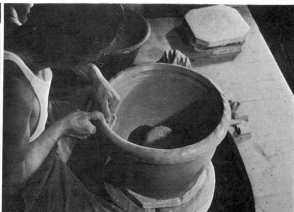

114. The coil is flattened.

115. The wheel is now turned more rapidly, and the coil is shaped by throwing.

116. The rim of the bowl is finished by smoothing with the fingers and chamois skin.

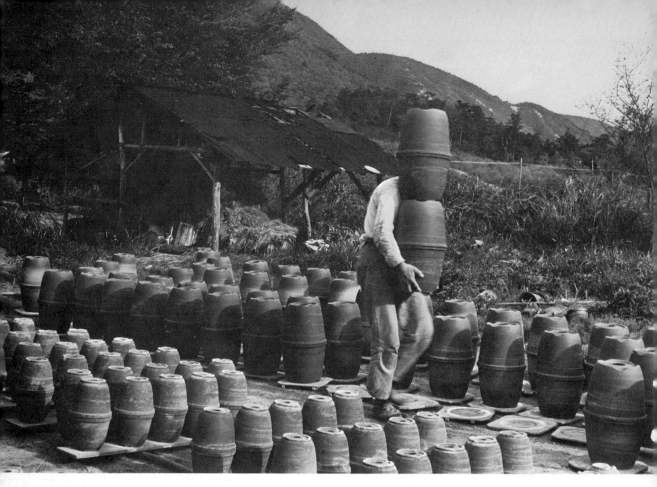

117. Leather-hard pots in the drying yard.

118. Planters drying in the sun. Molds are in the background.

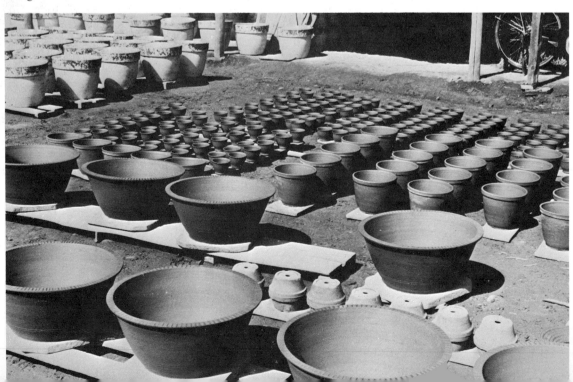

119. Glazing small pieces.

120. Bamboo tube slip trailer. This tool is unique to Tamba.

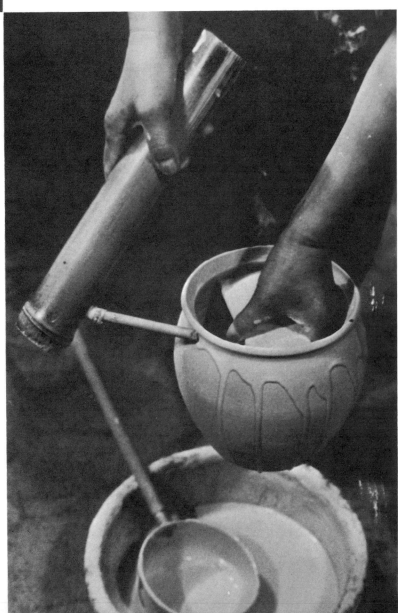

121. Using the bamboo tube to apply a drip pattern.

150

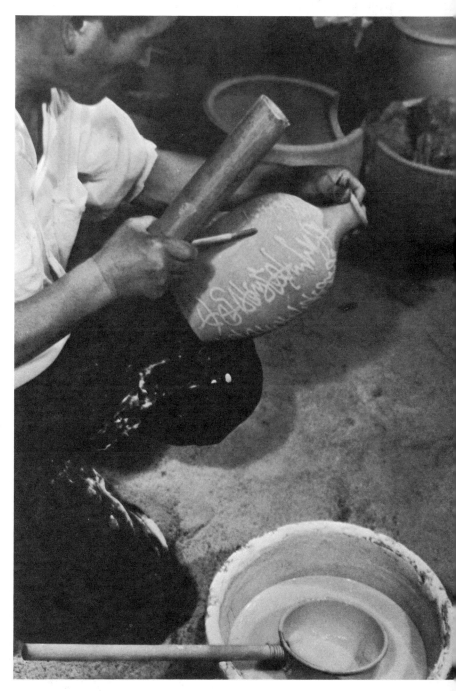

122. Trailing characters on a saké bottle with the bamboo slip tube.

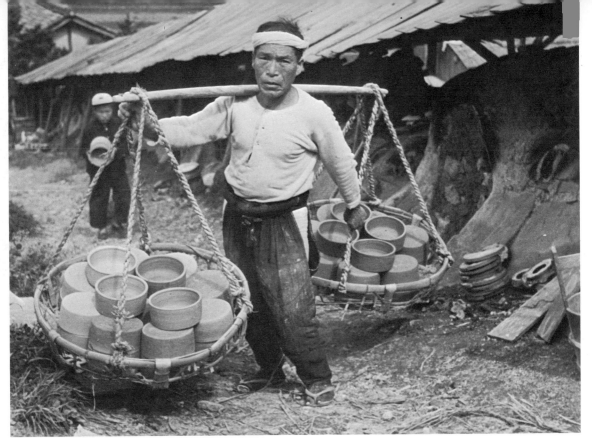

123. Potter carrying a load of small saggers.

124. Passing saggers into the kiln.

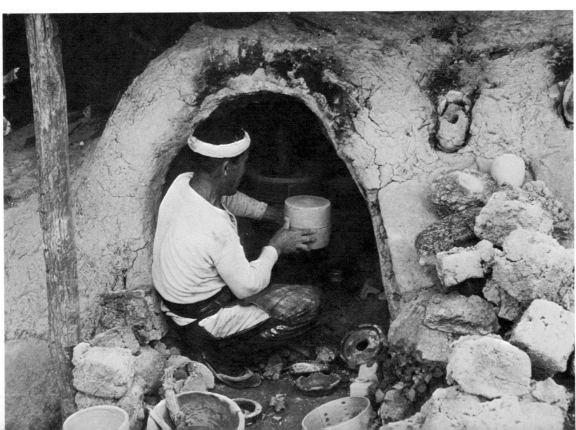

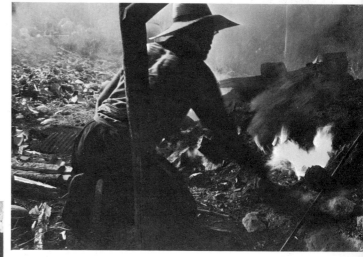

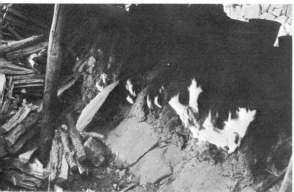

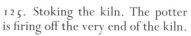125. Stoking the kiln. The potter
is firing off the very end of the kiln.

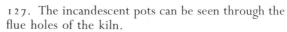126. Tongues of flame coming
from the stokeholes during a firing.

127. The incandescent pots can be seen through the
flue holes of the kiln.

128. Passing finished pieces out of the kiln after a firing.

129. Small pickle jars are removed from the planters in which they were fired.

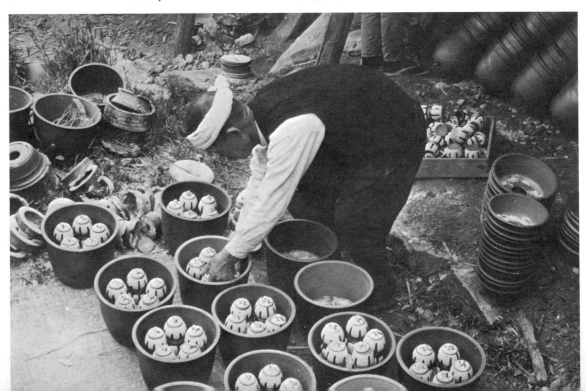

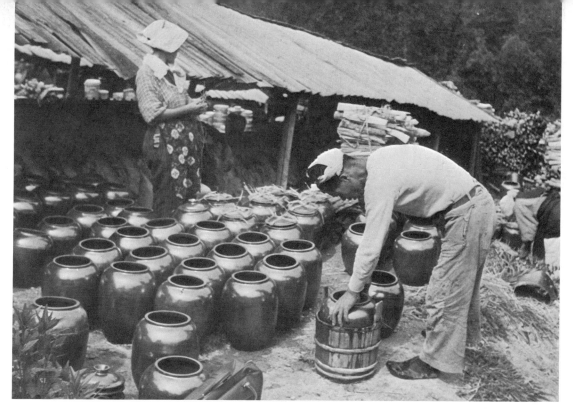

130. Water jars. The potter is testing for leaks by pushing the jar down into a bucket of water.

131. Schoolboy carrying finished water jars from the kiln.

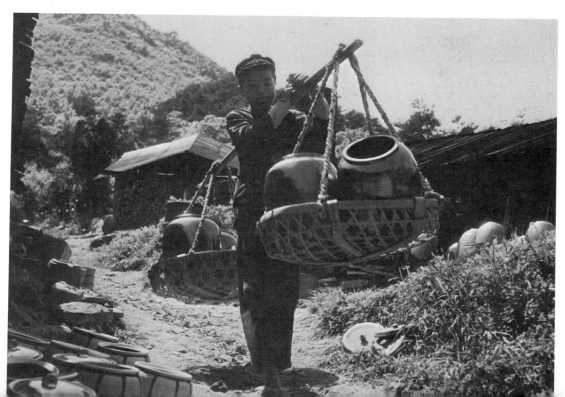

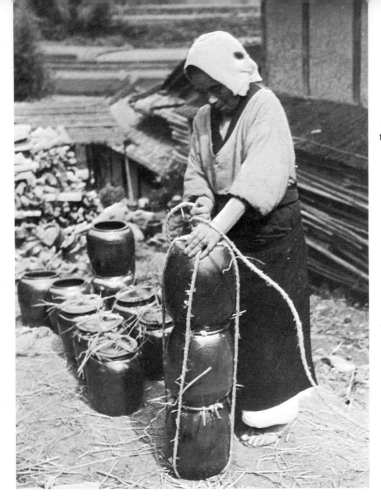

132. Tying up finished water jars for transportation.

133. Finished planters ready for shipment. Each pot is wrapped in its own rice straw and rope covering.

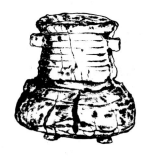

NOTES ON THE SIX
ANCIENT KILNS

DURING THE latter half of the Kamakura period and into the early Muromachi period, six different pottery localities were actively producing in spite of the general decline in ceramic activity in Japan which occurred at this time. They were Tamba, Echizen, Tokoname, Seto, Shigaraki and Bizen. These have been called the "Six Ancient Kilns." This designation is a little confusing, because there was in previous times a thriving pottery production at innumerable kiln sites. Actually the Six Ancient Kilns occupy a middle position in time—not particularly ancient as Japanese history goes, but keeping alive and transmitting into modern times the heritage of clay working as it had developed in older times.

Japanese lovers of pottery (and this includes a surprisingly large percentage of the population) have a special regard for the wares of the Six Ancient Kilns, and can instantly distinguish the product of one kiln from another. The reputation of the kilns was originally established by the devotees of the tea ceremony who collected old pieces whose rustic simplicity accorded with the cult of tea. Pots which had been originally

made for everyday use as containers or storage jars were put to use in the tea ceremony as water pots or flower vases.

A consideration of the other old ceramic centers may clarify the relative position of Tamba in the history of Japanese pottery. Actually, with regard to size, variety of ware, and influence, Tamba must be regarded as one of the lesser of these, but it survives to the present day much more intact and unchanged than any of the other ancient kilns.

ECHIZEN

Echizen and Tamba were much alike—obscure country pottery locations which served primarily local markets. At Echizen, however, production ceased long ago, sometime in the early part of the Edo period. The wares of Tamba and Echizen were frequently not distinguished from one another by collectors and art historians, especially those pieces dating back into the earlier period. Echizen was a region in what is now Fukui Prefecture. Some of the old kiln sites are known, and the form of the kilns can be reconstructed from the ruins. The kilns were similar to those at Tamba, but larger. Large jars were made, and they often have spectacular natural ash glaze coatings (Pl. 7). Little is known of the history of the kilns, but presumably pottery making at Echizen, as at Tamba, was a continuation or descendant of the Sue pottery, and began during the Kamakura period. Surviving pots are not numerous. The Echizen kilns may have become derelict because of competition from Tamba, or because that region did not benefit from the infusion of Korean methods during the Momoyama period.

TOKONAME

Tokoname pottery was made at Tokoname on the Chita Peninsula, bordering Ise Bay. It is not far from Seto. The peninsula is

sandy and rather barren, but there are excellent clay deposits, and this, presumably, is the reason for the development of pottery making there. Because of the plentiful clay, a ceramic industry has continued at Tokoname until the present day. Now the main products are brick, tile and sewer pipe, and the ancient pottery tradition no longer survives. Tokoname jars and vases from the Kamakura period are known. They are well made and rather graceful in form and sometimes have incised decorations accentuated by natural glazed areas and by flashing. Tokoname is best known for the large storage jars which were made there over a very long period of time. These jars, often more than two feet high, were made by the coil-and-throw method, from a coarse, sandy, brown clay. They are often rather asymmetrical and have a rugged yet graceful shape with a bulging shoulder and narrow base (Pl. 8). Transitions between coils are often quite apparent. Tokoname jars have turned up in various parts of Japan, and were probably shipped by sea. A large number of kiln sites have been located, indicating what once was a thriving production. Oddly enough, the style of Tokoname is quite distinct from that of Seto, even though the two areas are only about fifty miles apart. These two towns were certainly producing simultaneously throughout the history of the two industries.

There is a museum of pottery and ceramics at Tokoname built since the war, where one can see fine examples of the ancient ware. The museum is a handsome modern structure, built on a hill overlooking the dwellings and factories of the town. Connected with the museum, there is a research laboratory where a great deal of work has been done on investigating the old ceramic methods and materials.

SETO

Seto stands out from the other ancient kilns in several ways. Very early it became the largest producing center of ceramics in Japan, and it has remained so right down to modern times. Such a large percentage of Japanese pottery was made at Seto that the term *setomono* came to stand for pottery in general.

It is known that Seto was an important center for the production of Sue pottery and that this production continued into the early Kamakura period. The presence of excellent clay in large quantity probably accounts for the concentration of kilns in the area. At Seto the transition from Sue pottery to the later kinds of production seems to have been gradual, and it is doubtful if the kilns ever suffered much of a decline. The zenith of pottery making at Seto occurred during the later years of the Kamakura period and the early part of the Muromachi. Over two hundred kiln ruins from this period have been found in the hills near Seto. After this time, the quality, but certainly not the quantity, of Seto wares tended to decline.

Another distinguishing feature of Seto was the great variety of pottery which was made. Jars, flower vases, tea jars, tea caddies, ewers, shallow bowls, tea bowls and other accoutrements for the tea ceremony were made in a multitude of variations. Also made in large quantity were shrine figures such as guardian lions. Not only were many different forms produced, but a wide variety of forming techniques were used, including throwing, pressing into and over molds, coiling, modeling, and combinations of these.

The earliest true glazed stonewares of Japan were made at Seto. This important development of glazing technique is said to have resulted from contacts with China. Certainly at the time at which it occurred, during the first half of the thirteenth century, there was a renewal of contact with China. It was at

this time that Zen Buddhism was introduced to Japan, and the exchange of Buddhist priests and monks between China and Japan became quite frequent. Travelers to China brought back pottery from the Sung kilns, and these pieces were much admired by the ruling military classes. Early in the thirteenth century a legendary potter, Katō Shirōuemon, is said to have gone to China, accompanying the famous priest Dōgen, who is credited with introducing Zen to Japan. Shirōuemon stayed in China several years, working at Chinese potteries and learning the secrets of glazing. Shirōuemon returned to Seto and found there the necessary materials to make glazed wares. There may be something to this story; certainly there was a rather abrupt appearance in Seto of Chinese-style pottery very much related to the contemporary work of the Southern Sung and Yüan dynasties (1127–1367). And there is a certain attraction in the story in that it connects an important innovation in Japanese pottery with the introduction of Zen Buddhism and thus points up the possible connection between these two endeavors.

If a potter named Shirōuemon actually did go to China and study Sung pottery making, his attempt to reproduce it in Japan was only a qualified success. The Sung-style jars made at Seto turned out to be quite different from their prototypes. These narrow-necked jars are somewhat more squat than the Chinese, and by comparison seem clumsy. The foot is usually flat and is crudely finished. Designs were incised into the clay (Pl. 141). The great majority of these designs are floral, but occasionally a fish motif was used, or a calligraphic inscription. The glaze, probably intended to be celadon, is yellowish or straw colored. It is evidently a compound of ash, clay and some iron-bearing mineral. Such a glaze would certainly have formed a successful green or olive-colored celadon if it had been fired in a sufficiently reducing atmosphere. However, the Japanese kilns of the time were apparently incapable of reaching the

high temperature required to melt the glaze and of being held in reduction at the same time, and the results were usually those of an oxidizing or neutral fire. While the yellow Seto glaze lacks the depth and mystery of Chinese celadon, it has certain charms of its own and seems to fit well on the rather sturdy, plain shapes. Later, a darker iron glaze appeared, which also was probably made up principally of ash, but with more iron added. This darker amber glaze gave emphasis to the incised or stamped lines on the surface of the pots, and often shows a flowing or streaked quality.

Another Seto glaze which was developed during the Kamakura period is the brown iron glaze called *temmoku*. This glaze was made from a local iron-bearing rock, which outcrops in many places in the region of Seto, combined with ash. As in the case of celadon, this Japanese version of *temmoku* never equaled the sumptuous color and surface markings of the Chinese model. Nor did the Japanese *temmoku* tea bowls equal the subtlety of form of the original Sung pieces.

If one views these somewhat derivative Seto pots from the viewpoint of Chinese standards and forms, they may be found wanting. They have many obvious technical flaws, such as imbedded kiln crumbs in the glaze and streaked, uneven glaze application. The workmanship could be considered careless. The incised designs are rather brusque and lacking in sinuous grace. But even though these pieces may have been directly inspired by Chinese models, they are nevertheless unmistakably Japanese, and they have a charm peculiarly their own. Their very flaws seem to put us closer to the ceramic process and to lend a warmth and human quality. What they miss in sophistication and suavity they make up for in rugged strength and vividness. In them we can readily sense the slow turn of the potter's wheel, and the mark of the tool as it traces a husky peony design. We can feel also the violence of the fire, which

certainly burned in features not consciously intended by the potters.

Later developments at Seto included the perfection of porcelain in the eighteenth century. Seto porcelains, however, were inferior to those of Kyushu, and the mainstay of the kilns continued to be stonewares, manufactured in quantity and widely distributed. Seto had an advantage over other ceramic centers in having large quantities of excellent light burning clay (still far from exhausted), and a central location convenient to coastal transport. In modern times, its wood supply has been completely exhausted, and firing is accomplished with coal or oil.

The visitor to contemporary Seto would hardly guess that in the hills which surround the city there are many ruins of the old *anagama*, cave kilns, once the scene of pioneering efforts of Japanese potters to bring their techniques nearer to the high standards of the continent. Near Seto we were taken to such a kiln and were actually able to crawl into it. The interior was about fourteen feet long, six feet wide, and four and a half feet high. Roots grew down into the kiln, giving an eerie effect. The walls of the cave plainly showed the effect of the firing. The surface was crusted over with burned, semi-vitrified earth. Near the entrance to the kiln were many broken shards and discarded fragments of bowls stuck together from overfiring, and we were able to identify some of these as being from the Kamakura period. This ruin, which has not been fired for some hundreds of years, stands unmarked near a small country road. The modern city has countless ceramic plants of all sizes, producing a bewildering variety of products. When the wind dies down, a pall of smoke from the kilns hangs over the valley, and at night one can see the plumes of flame coming intermittently from the tall chimneys as the fires are stoked with coal.

The productions of Seto have perhaps been too varied and

numerous to be considered as one ceramic style or expression, but among the diverse examples of the early period can be found some of the greatest Japanese pottery.

Shigaraki

Shigaraki is a charming town in the hills not far from Kyoto. Pottery has been made there since very early times, and is still the main occupation today. Sue pottery was probably made in the area, and there is a legend that Korean potters settled there in the twelfth century. As with the other ancient kilns, the Shigaraki wares of the Kamakura period can be thought of as descendants of the older gray unglazed wares of earlier times.

The clay at Shigaraki contained granular impurities of feldspar, and these mineral fragments appear in the finished pots as small, white, partially melted spots or beads. In the early rudimentary kilns the clay fired to a pleasant blond tan, or reddish tan, and this natural color, enlivened by flowing areas of natural ash glaze, or by darker flashes, gave great richness to the pottery. The impurities in Shigaraki clay could easily have been eliminated by flotation, but this was not done. This brings up again an interesting feature of old Japanese pottery, its reflection of the idiosyncrasies of local materials. Of course the original occurrence of the little chips of feldspar in the clay was fortuitous, and the fact that the potters did not screen them out may have indicated a deterioration of control over the materials following the decline in the manufacture of Sue wares. The appearance of this natural texture traceable to the nature of the clay in that particular locality must have been welcomed and cherished, because for a period of several hundred years the effect persisted without change. Even today, although most forms are made with smooth clay, potters in Shigaraki sometimes add ground feldspar into the clay to achieve the familiar

old texture recognized everywhere as the mark of Shigaraki. Such local traditions in Japanese pottery have been remarkably durable and have made the problem of distinguishing the product of one kiln from another more simple than it otherwise would have been. Characteristic of early Shigaraki wares were splendid rounded jars, often quite symmetrical, and smaller jars with simple line-scratched decorations on the shoulder. Also common were straight-sided jars. All of these shapes evidently functioned as agricultural or domestic storage jars. They were potted quite roughly and casually, and must have been made in considerable quantity (Pl. 10).

IGA

In the neighboring town of Iga, a production was carried on quite similar to that of Shigaraki. However, during the Momo-yama period, Iga turned to the making of tea wares, and its pottery then took on a distinctive style of its own. The Iga wares were much influenced by Furuta Oribe, the samurai tea master who is known to have visited Iga in the early 1600's. He wrote a letter, still extant, which verifies his stay there. Oribe is also said to have made a waterpot at Iga, which was the proto-type of the famous Iga *mizusashi*, or the tea ceremony water vessel. Oribe's piece, still in existence, has no ears at the side, such ears being a common feature of many Iga pieces. But it does clearly show most of the style features of the developed Iga ware: rather crude potting, a thin, irregular glaze, some markings of the tool or spatula, and areas of scorch or burn where the glaze darkened and deteriorated (Pl. 11).

Iga ware is a good example of the tendency of native peasant pottery traditions to degenerate when they came under the influence of the sophisticated tastes and ideas of the tea cult. When it was first felt, this influence was salutary, and a fusion

occurred between the sturdy health of the native potters and the ideas of Oribe. This resulted for a time in pottery which was at once strong and vigorous, and had also subtleties and nuances which were highly cultivated. The Iga ware was admired for its roughness, flaws, and the marks of the intense fire. But as it came to be in great demand for the tea ceremony, the potters learned to seek out or to contrive these effects directly, rather than accepting them as they came. What had been a perfectly natural result of process became a self-conscious striving for eccentricity. Many a prized Iga piece has an artificial crack which was carefully carved by the potter into the raw clay before firing.

BIZEN

The kilns of Bizen, which were located in the neighborhood of Imbe in Okayama Prefecture, presumably inherited the traditions and methods of the Sue, but, as in other locations, some skills in throwing seem to have been lost, and less control was used in the preparation of clay. After the Heian period, Bizen potters became concerned largely with the making of utilitarian wares for agricultural use rather than with ceremonial, temple or burial wares. During the early Kamakura period, production at Bizen seems to have been largely of seed storage jars, and these were made of a dark-burning, rather dense clay.

In spite of humble origins and everday function, the old Bizen wares are among the most distinctive in Japanese ceramics and are given an ''old master'' value by contemporary collectors. The unique character of the ware seems to have grown out of a purely local and indigenous style of potting, which, as it developed, had almost no resemblance to the earlier Sue, and was unaffected by any outside influence. Much of the distinction of Bizen stems from the local raw material

and the way it was fired. The clay was a very impure surface clay, high in organic content and containing considerable iron. As still used today it is very smooth, fine grained, and rather sticky. When fired to about 1200° C., this clay, unpromising by ordinary standards, gave a very dense, hard body, impervious to moisture and almost self-glazing. The density of the clay and its excessively high shrinkage caused much cracking and warping, and in order to get a reasonable percentage of work successfully through the firing process, it was necessary to lengthen the firing greatly beyond the normal time. This excessively long firing, perhaps six or seven days, necessitated by the nature of the clay, gave certain of the pots an unusually heavy build-up of ash glaze deposit. The long firing at a temperature rather higher than the clay could safely take, produced a reddish or mottled red to black color, and this, together with the sometimes spectacular spread of ash glaze on one side or on top of the pot, gave the Bizen ware its unmistakable color and texture. Fire flashings, prominent because of the high iron content of the clay, were common. No slips or glazes were ever used (Pl. 12).

Another feature which distinguishes Bizen pottery is the appearance of reddish-brown markings or patterns on the surface. These markings, which resemble fire flashing, are called *hidasuki*, translated roughly as fire cords (Pl. 149). They are caused by the contact of straw or other organic material with the surface of the pots during the firing process. It is possible that the use of straw was originally intended merely as a device to cushion and protect the ware as it was being loaded into the kiln, and was not calculated to produce a decorative effect. Straw was put between and around the pieces, especially when one piece was nestled inside another. The straw made a print on the finished ware, the effect of the residue of ash from the burned material. Perhaps in some cases the straw was

soaked in brine to further accentuate the effect. Pine needles, used occasionally, gave a more diffuse, mottled effect.

Bizen ware, because of the way it was made and fired, has an unusual degree of variation. Some pieces are very dark and clinkerlike, others are quite light buff or salmon color. The lighter pieces were fired in the cooler sections of the kiln. Losses in the kilns must have been very high because of the tendency of the clay to warp and crack; even today at Imbe a thirty percent loss is considered acceptable. The firing was actually carried to the danger point of overfiring. Perhaps this overfiring was an attempt to obtain a vitreous, watertight pot without the use of glaze.

The older Bizen pots were rather thick and stolid, sometimes almost ponderous in shape. The more sophisticated works made in the Momoyama period under the influence of the aesthetics of the cult of the tea ceremony became lighter, and also more varied in shape. The potting at this time became markedly more fluid and plastic, perhaps as a result of an unconscious effort to counteract the somewhat metallic character of the dense, hard-fired, and brittle clay.

The tea masters collected old Bizen works with enthusiasm, and pots originally made as seed jars were fitted out with lacquer lids and used as waterpots in the tea ceremony. Their rather somber and restrained color and shape, shadowy and reminiscent of darkened autumn leaves, accorded perfectly with the astringent and understated character which was desired in the accoutrements of tea. In the Momoyama period, the potters in Bizen began to make wares specifically for the tea ceremony, particularly flower vase forms. In the late 1500's, Takeno Jō-ō is said to have gone to Bizen and to have launched the potters on the production of tea wares. Jō-ō, Zen devotee and son of a samurai, was one of those arbiters of taste who so effectively steered the course of Japanese art.

The great period of Bizen pottery was in the Momoyama period, and soon after the beginning of the Edo period the style deteriorated. Bizen ware then became rather mechanical in feeling—very smooth, dense and with a somewhat "oily" surface. Figurines became quite an important part of the production. Perhaps this decline could be attributed to the sudden fame which came to the kilns as a result of the patronage of Toyotomi Hideyoshi, who during a military campaign actually stayed for a time in Bizen and lived with a potter there. He tried his hand at the clay and developed a great enthusiasm for the Bizen ware, which he ordered made for his own use in the tea ceremony. He also named six families in Bizen as "specially designated" potters. This incident, which greatly increased the prestige of Bizen pottery, would be comparable to George Washington having taken up potting for a time at some old colonial shop, and having recommended such wares to the use of the Congress. It could only happen in Japan!

At its best, Bizen has an incomparable subtlety and beauty of clay surface. Warm and cool colors play across it, and the variety of color in the ash-glazed portions seems endless. The print of the straw appears now as a distinct pattern, now as a natural event, in no sense contrived or predetermined. In Bizen ware, we feel the fire as a palpable force, and here process and result are as one. The forms of the pots at times seem melted, shattered, or transformed by the heat. The mutations of color often give a sense of the direction of flames. Round spots of color appear on the surface of plates and flat forms, speaking of missing pots which formed the spot by protecting it from flame and ash. Inseparable from the fire marks and from the clay texture is the play of tool and spatula—cuts, dentings, striations, and the mark of the fingers on the turning pot— sometimes coarse, sometimes more gentle and rhythmic. Grog and other coarse particles are embedded in the dense

clay, giving a cementlike texture to some pieces. The pots are rather heavy. They usually sit on flat, broad bottoms. One seldom feels any sense of exceptional skill in them, or of careful craftsmanship in the usual sense. They seem more like natural events, guided a bit, perhaps, by hand and mind, but by no means thought out or planned. They skirt the edge of value-lessness, yet are precious and unique.

The early pottery of Tamba and of the other Ancient Kilns is entirely the work of anonymous craftsmen, folk artists whose names do not appear even as signatures on the pots, much less in the annals of history. In fact, most of the great pottery of the past the world over was similarly created by unknown persons. Yet these pieces speak to us as works of art, in some cases as great works. Clearly, our concept of art as being the work of individual genius and the working out of some unique and special individuality must be revised or broadened to accommodate the fact of these pieces. We can be sure that the humble potters who created the Tamba jars were not striving for self-expression, for distinction, for uniqueness, for great-ness or for immortality. Rather, they were functioning as ordinary men, reacting with wholeness to the conditions of their lives and to the materials under their hand. Their pots were not different from themselves, and are in fact a tracing of life, of consciousness and of sensibility on a basic level. Clay, especially, is a material exceptionally sensitive to the nuances of manipulation, and its given form is a telltale indicator of the spirit of the maker. If this is so, we can only admire the men who produced these unpretentious pieces, works lacking any hint of affectation, so forthright in form and function, so timeless in shape, so natural in color and texture. In these pots, man and his ambience meet in harmony.

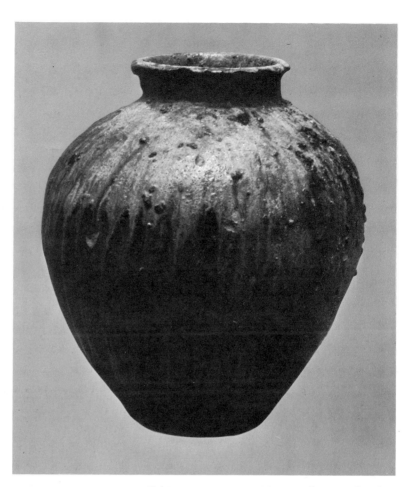

134. Echizen storage jar. Muromachi period. This massive, powerfully shaped vessel is one of the finest of the surviving old Echizen pieces. *Height:* 15.1 in.

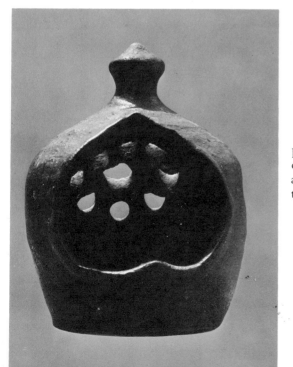

135. Echizen charcoal carrier. Early Edo period. This unusual shape was used to carry hot coals from one hibachi to another. It was sculptured from a wheel-thrown form. *Height:* 9.0 in.

171

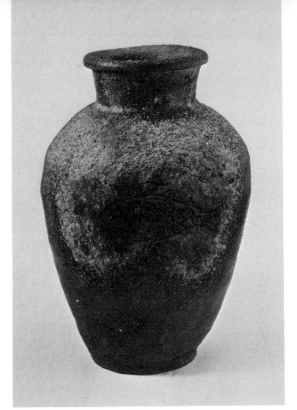

136. Storage jar. Muromachi period. The attribution of this piece is in doubt, but the shape strongly suggests Echizen. The incised design, however, is certainly not typical of Echizen pottery. *Height:* 9.8 in.

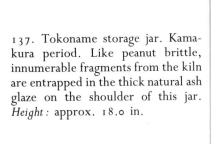

137. Tokoname storage jar. Kamakura period. Like peanut brittle, innumerable fragments from the kiln are entrapped in the thick natural ash glaze on the shoulder of this jar. *Height:* approx. 18.0 in.

172

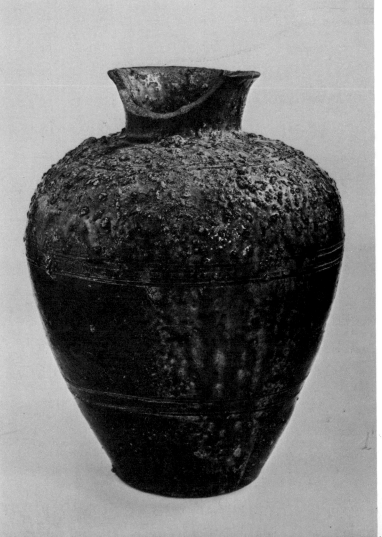

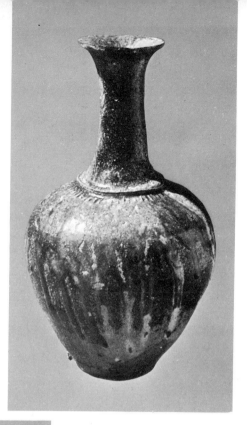

138. Tokoname narrow-necked vase. Kamakura period. The neck was thrown separately and luted to the body. During the Muromachi period throwing techniques became much looser at Tokoname. *Height:* 11.0 in.

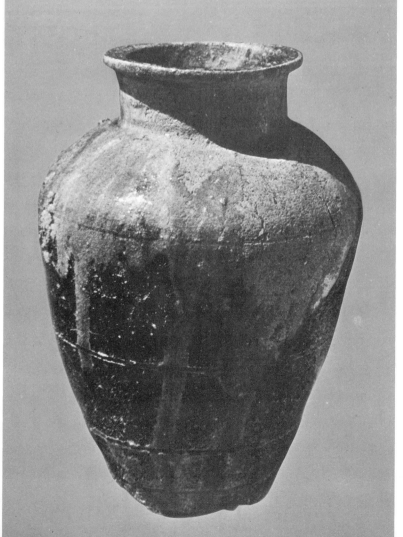

139. Tokoname jar. Kamakura period. Part of the natural ash glaze on the shoulder has flaked off, revealing the coarse, gray clay. *Height:* 13.0 in.

173

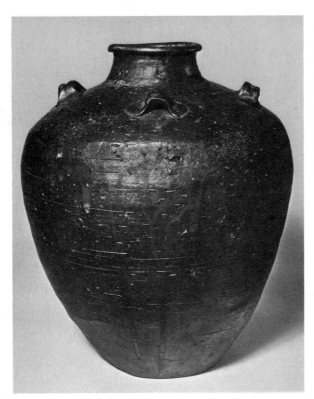

140. Seto tea jar. Momoyama period. This powerfully formed piece has functioning lugs for tying down a lid. The clay body contains mineral fragments which have caused surface cracking and striations where the potter scraped the clay as it revolved on the wheel. *Height:* 12.5 in.; Courtesy of the Smithsonian Institution, Freer Gallery of Art, Washington, D.C.

141. Ko ("Old") Seto jar. Kamakura period. The glaze on this beautifully incised piece is a transparent yellow amber. *Height:* approx. 16.0 in.

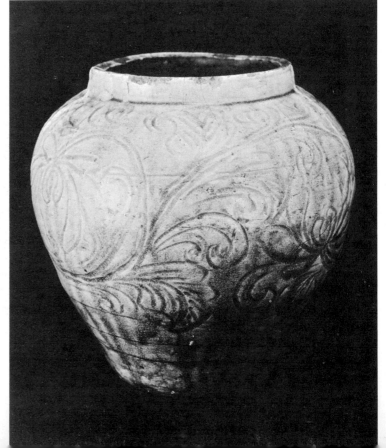

142. Shigaraki storage jar. Muromachi period. The natural ash glaze here grades from gray to a whitish yellow, making a striking contrast with the scorched red of the clay body. *Height:* 16.9 in.

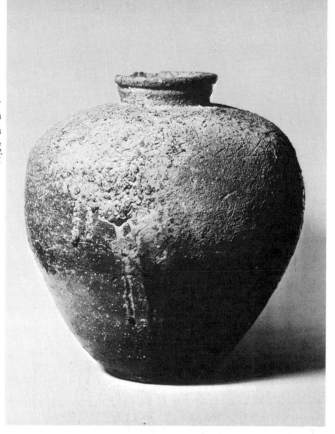

143. Shigaraki jar. Muromachi period. The quiet, unassuming strength of this piece is typical of Shigaraki of the Muromachi period. *Height:* 17.5 in.

144. Shigaraki storage jar. Muromachi period. The rough clay of this dark gray jar has flaked off in places during firing. *Height:* 12.3 in.; *Collection:* Shigaraki Ceramic Research Institute

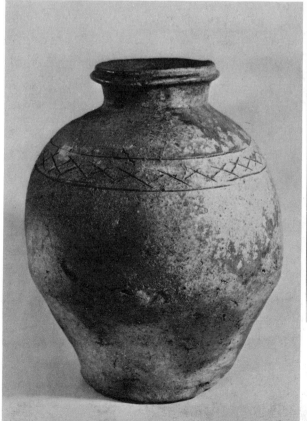

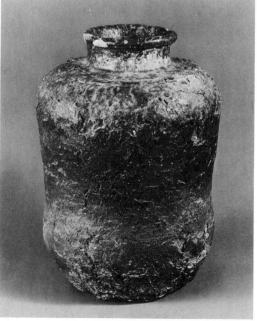

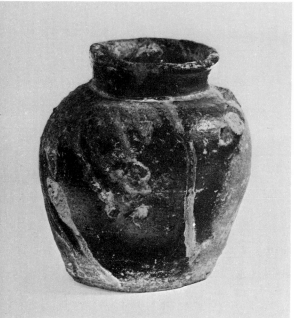

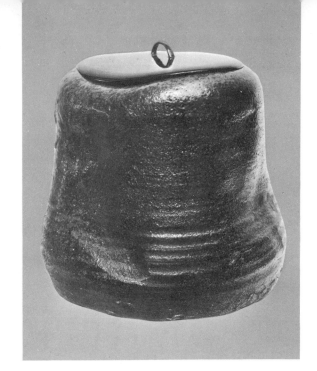

145. Storage jar. Kamakura period. This is a famous piece in Japan, where it is classified simply as a *uzukumaru tsubo* or "squat pot." Some authorities believe it to have been made in Bizen. The vagaries of the fire have given a remarkable richness to the surface. *Height: 8.5 in.*

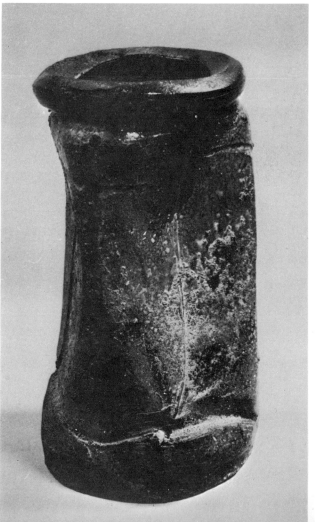

147. Bizen vase. Momoyama period. Although this vase is essentially a simple cylinder, the alteration of the form by quick strokes with a bamboo tool has given it an active, dynamic form. The encircling accent at the bottom and the strongly shaped collar define and constrain the sculptural movement of the middle section. *Height: 10.1 in.*

146. Bizen water jar. Momoyama period. A compact, rounded form made on the wheel and altered while still soft. Although the pot is covered with a thin coat of ash glaze, it has a somewhat rough and pebbly surface. The lacquer lid, as is the custom with tea ceremony water containers, was specially made to fit the contour of the pot. *Height:* 7.5 in.; *Collection:* The Metropolitan Museum of Art, Fletcher Fund, 1925, New York

148. Bizen vase. Early Edo period. The fire has given the clay a mysterious silvery gray color except for the two spots, which are light, warm brown. This simple compact form seems charged with latent energy. *Height:* 10.0 in.

149. Bizen storage jar. Muromachi period. This compact and dignified jar is a classic of the older Bizen style. The clay is brown, with the mysterious *hidasuki* marks from the straw breaking up the surface. The lip has been partially restored. *Height:* 16.5 in.

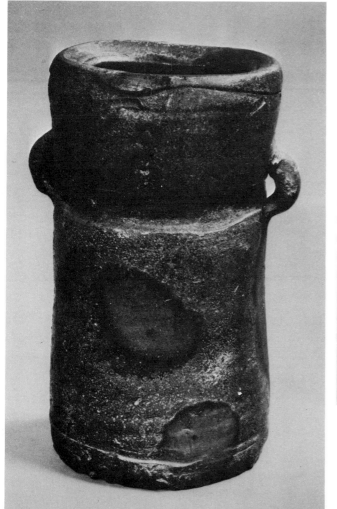

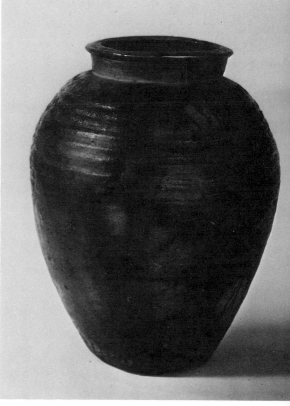

150. Iga tea ceremony water jar. Momoyama or early Edo period. The color is warm gray with some gray green where the glaze is thicker. The softness and pliability of the clay finds expression here without any trace of weakness or incipient collapse. *Height:* 8.2 in.; *Collection:* Shigaraki Ceramic Research Institute

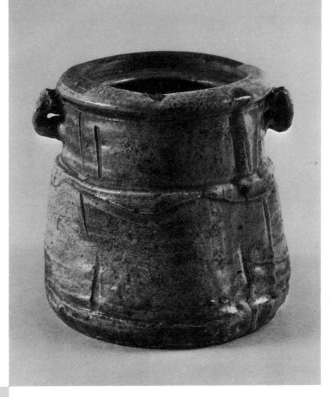

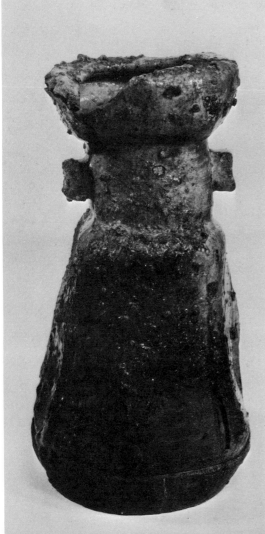

151. Iga vase. Momoyama or early Edo period. This craggy pot is famous in Japan. The upper part, broken and scorched, has suffered the extremity of the fire. It is probable that Iga pots of this type were fired several times to achieve the desired complex range of color and texture. *Height:* 11.2 in.

BIBLIOGRAPHY

De Bary, William T., ed. *Sources of Japanese Tradition*. New York: Columbia University Press, 1958.

Embree, John F. *Sue Mura, A Japanese Village*. Chicago: University of Chicago Press, 1939.

Gorham, Hazel H. *Japanese and Oriental Ceramics*. Yokohama: Yamagata Printing Co., 1951.

Koyama, Fujio. *Japanese Ceramics*. Oakland: Oakland Art Museum, 1961.

Leach, Bernard. *A Potter's Book*. London: Faber and Faber, 1940.

————. *A Potter In Japan*. London: Faber and Faber, 1960.

Lee, Sherman E. *Tea Taste In Japanese Art*. New York: The Asia Society, 1963.

Miller, Roy Andrew. *Japanese Ceramics*. Tokyo: Toto Shuppan, 1960.

Munsterberg, Hugo. *The Ceramic Art of Japan*. Rutland, Vermont: Charles E. Tuttle, 1960.

Okada, Yuzuru. *History of Japanese Ceramics and Metal Work*. Tokyo: Toto Shuppan, 1953.

Okakura, Kakuzō. *The Book of Tea*. Rutland, Vermont: Charles E. Tuttle, 1958.

Rhodes, Daniel. *Kilns*. Philadelphia: Chilton Books, 1968.

————. *Stoneware and Porcelain*. Philadelphia: Chilton Books, 1959.

Sanders, Herbert. *The World of Japanese Ceramics*. Tokyo: Kodansha International, 1967.

Tadanari, Mitsuoka. *Ceramic Art of Japan*. Tokyo: Japan Travel Bureau, 1949.

Warner, Langdon. *The Enduring Art of Japan*. New York: Grove Press, 1952.

In Japanese:

Tadanari, Mitsuoka. *Shigaraki, Iga, Bizen, Tamba*. Tōki Zenshū [Complete Ceramic Series], vol. 6. Tokyo: Heibonsha, 1961.

Sekai Tōji Zenshū [Ceramics of the World], vols. 2, 3. Tokyo: Kawade Shobō, 1961.

Sugimoto, Katsuo. *Tamba no Yakimono* [Pottery of Tamba]. Kyoto: Heiandō Books, 1963.

Yabuchi, Kyoshi. *Tachikui-gama no Kenkyū* [A Study of Tachikui Kilns]. Tokyo: Kyoto Daigaku, Jinbun Kagaku Kenkyūjō [Kyoto University, Research Institute of Humanistic Science], 1955.

Yanagi, Sōetsu. *Tamba no Kotō* [Old Pottery of Tamba]. Tokyo: Nihon Mingei Kan, 1956.